HOLLYWOOD

ALSO BY KEEGAN ALLEN

life.love.beauty

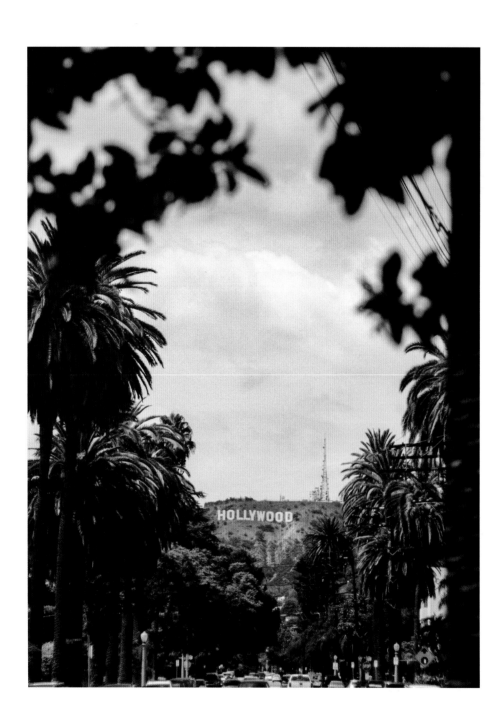

HOLLYWOOD

★

PHOTOS AND STORIES
FROM FOREVERLAND

Keegan Allen

St. Martin's Press New York

www.stmartins.com

Designed by Steven Seighman

The Library of Congress Cataloging-in-Publication Data is available upon request.

ISBN 978-1-250-08602-0 (hardcover)
ISBN: 978-1-250-20043-3 (signed edition)
ISBN 978-1-250-08604-4 (ebook)

Our books may be purchased in bulk for promotional, educational, or business use. Please contact your local bookseller or the Macmillan Corporate and Premium Sales Department at 1-800- 221-7945, extension 5442, or by email at MacmillanSpecialMarkets@macmillan.com.

First Edition: April 2018

10 9 8 7 6 5 4 3 2 1

Mom and Dad,

You taught me to believe in myself and gave me the world to play in. Without a camera, our memories would just be whispers in the dark.

Love,

Keegan

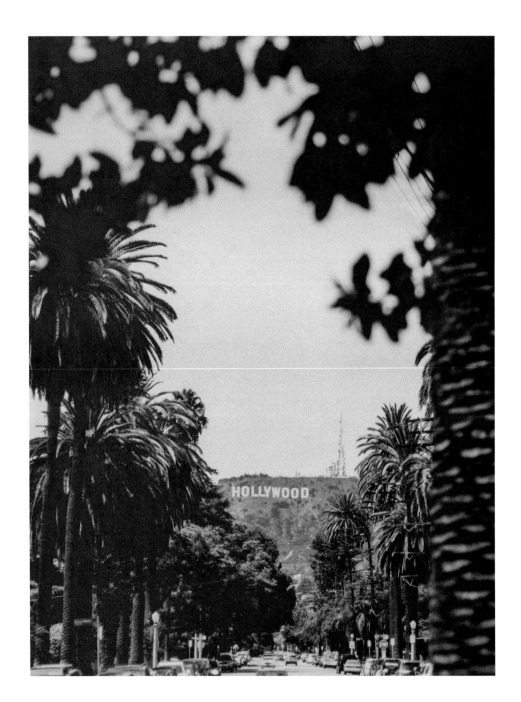

As an artist and writer, I love taking other people's pictures and hearing their stories, some real, some imaginary. I wrote and, in some cases transcribed, the short first-person vignettes included in the final pages of this book. The poetry is mine, too. But please note that although the voices and narratives informing these passages are informed by real people and real life, they do not refer to me, and they do not refer to the individuals whose images appear before or after them in the pages of this book. Instead, they are intended to be anonymous and in some cases mysterious, an invitation into Hollywood's many facets through my lens. Any similarity between the names and characters included in those passages and people whom readers know or are acquainted with, is inadvertent and purely coincidental.

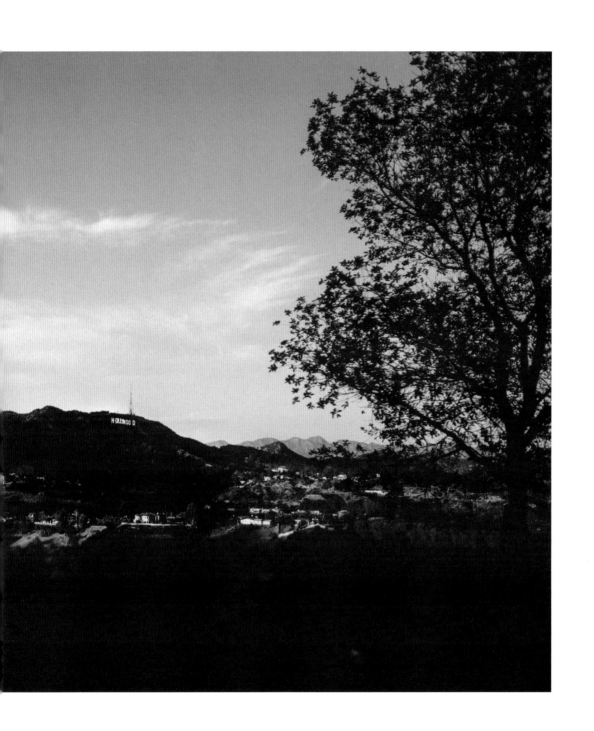

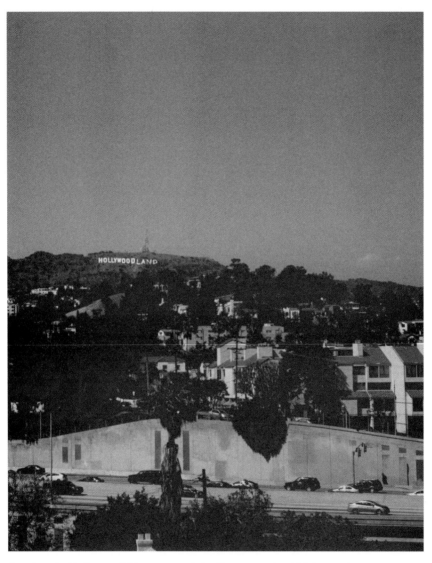

The iconic Hollywood Sign was originally put up in 1923 to advertise a real estate company. It read HOLLYWOODLAND when it made its first appearance on Mount Lee in the Santa Monica Mountains. The name Hollywood was conceived by H. J. Whitley, who was the real estate developer. In 1949, the sign was shortened to simply HOLLYWOOD.

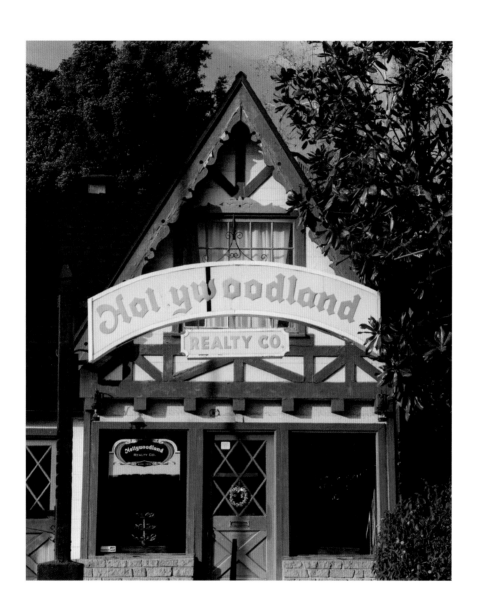

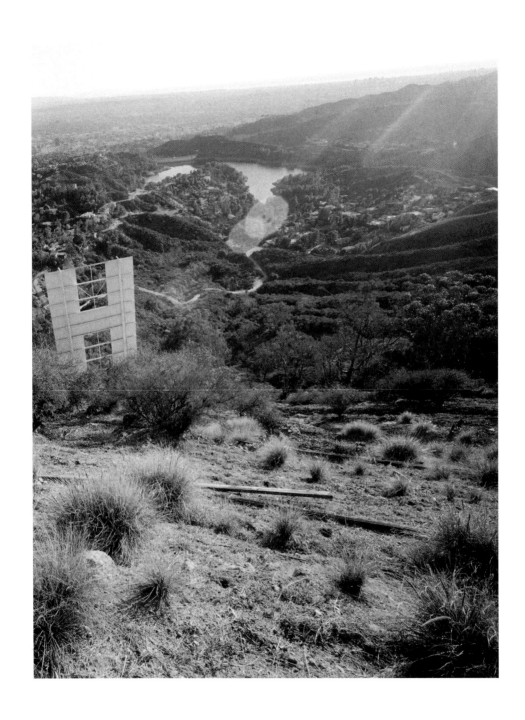

Hollywood's moody afternoon sky.

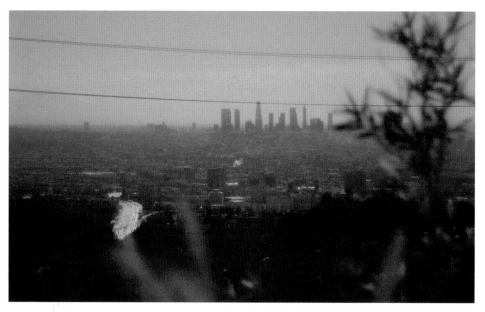

Long after Hollywood was developed, Downtown became the skyscrapers on the horizon that it is today.

Hollywood Boulevard, the Walk of Fame, and the iconic palms are all part of the dream that draws people to this place. There are success stories of men, women, boys, and girls who fought against all odds and faced their fears of rejection with constant power and ambition to be examples of greatness.

Many of these souls have found a wonderful life and love, and continue to create beautiful things here.

They pave the way for others to believe in themselves, create, and share. They rise above all the darkness and find peace.

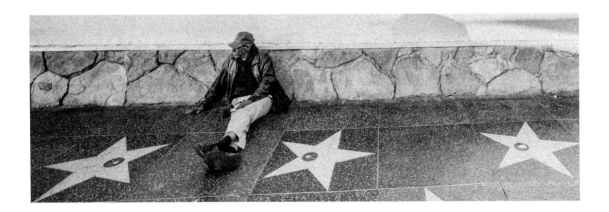

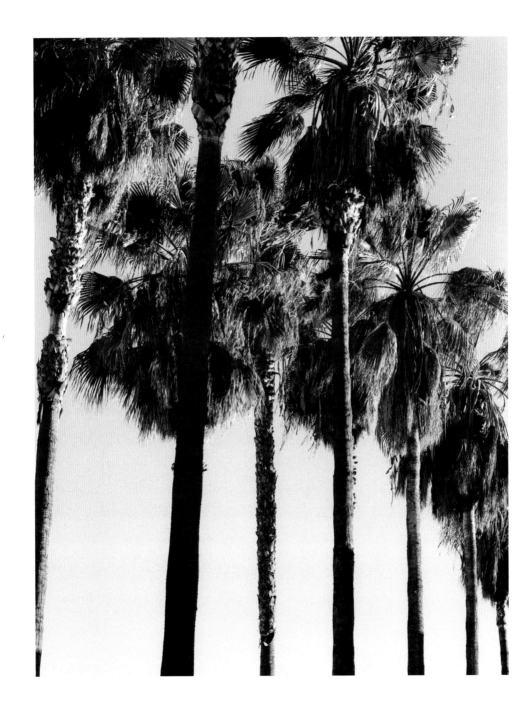

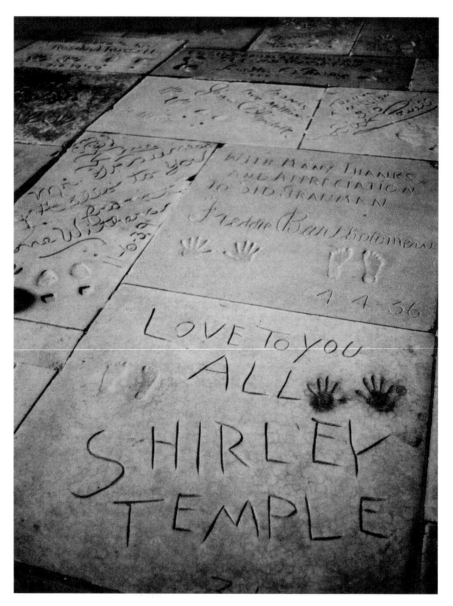

Along the Hollywood Walk of Fame is Grauman's Chinese Theatre. More than two hundred celebrity handprints, footprints, and autographs populate the concrete of the theater's entrance, eternally tried on for size.

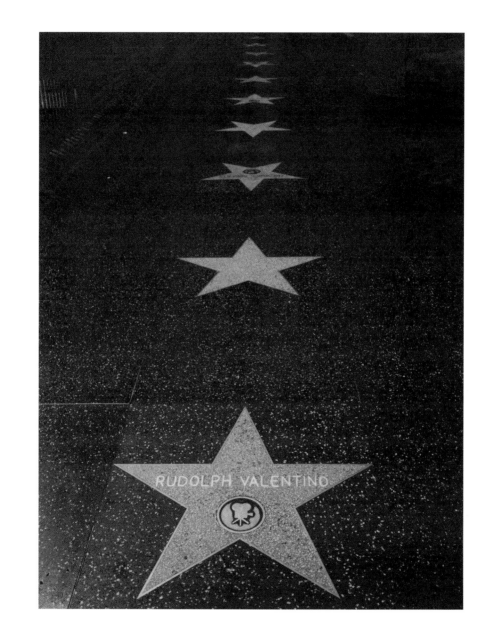

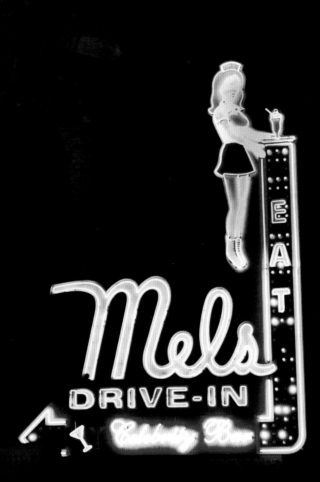

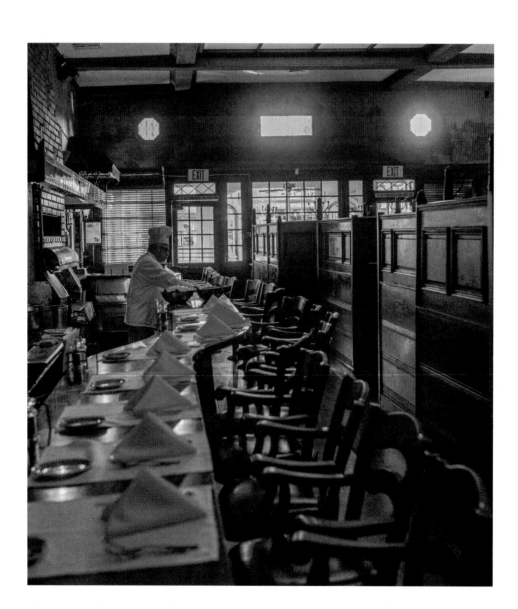

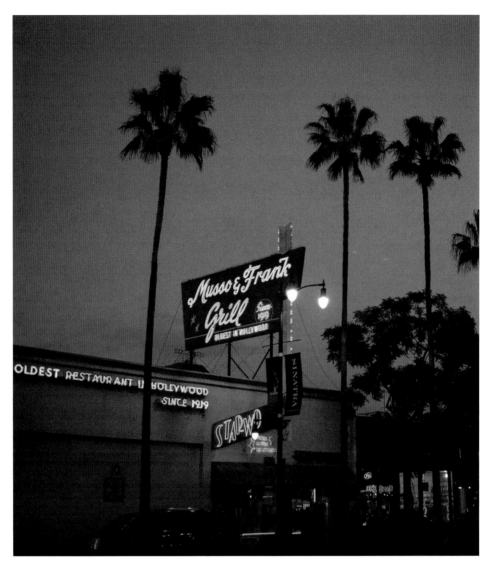

As a child, I knew it was a special night when my father said, "We are going to Musso & Frank." This iconic, nearly century-old grill served the likes of Charlie Chaplin and Douglas Fairbanks after they would race horses down Hollywood Boulevard with Rudolph Valentino watching . . . and it still serves up history and some legendary stories to this day.

Chateau Marmont lives off Sunset Boulevard and has long been an oasis for celebrities and privileged out-of-towners.

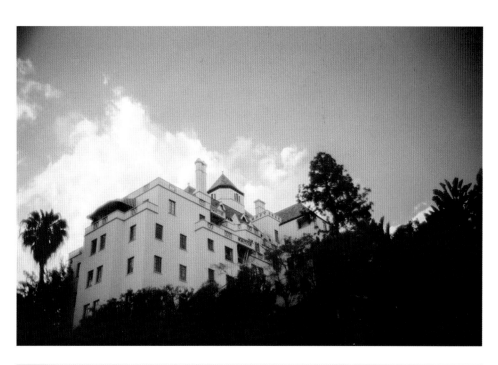

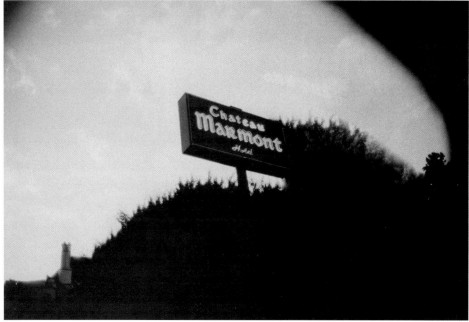

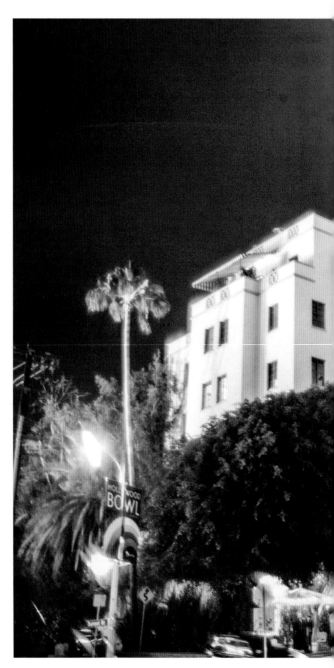

Chateau has many stories to tell.

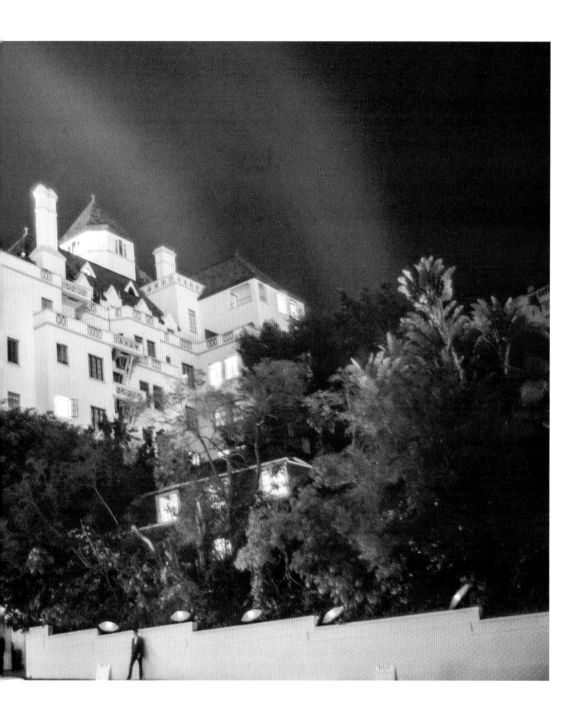

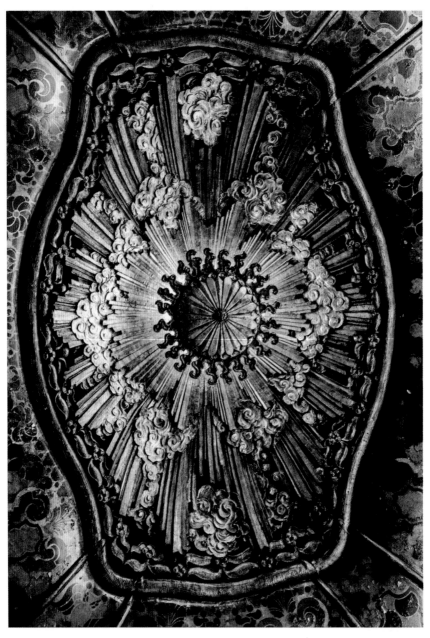

Ceiling detail of the famous El Capitan Theatre on Hollywood Boulevard.

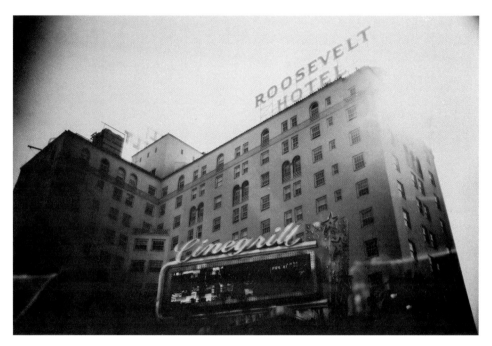

Another landmark hotel from Hollywood's golden age. The first Oscars were held in the great hall of the Hollywood Roosevelt Hotel.

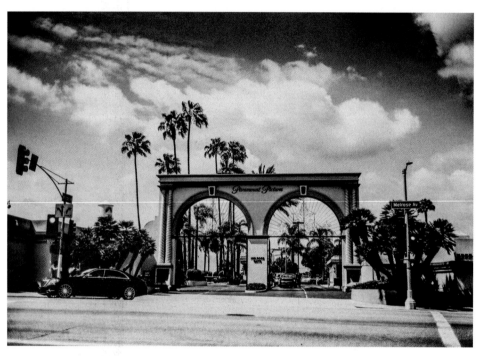

The famed gates of Paramount Pictures Studio. Some people never get through.

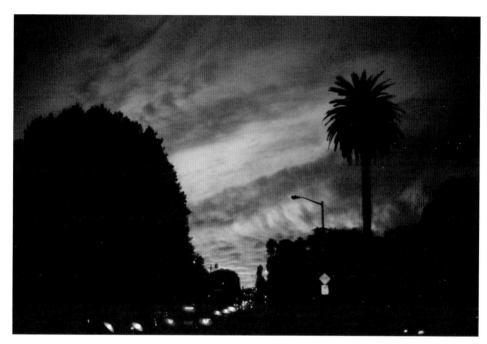

Night falls on the dreamers.

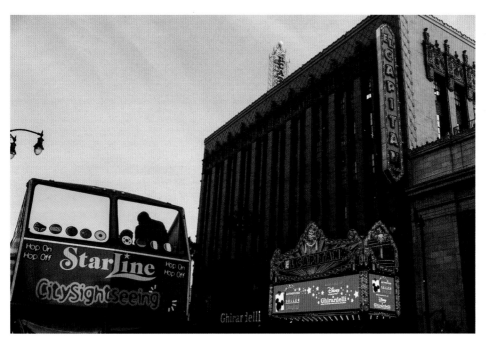

Visit the dreams up close.

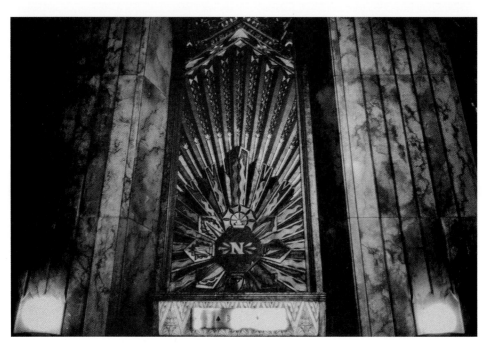

Art Deco design is also part of this town's history.

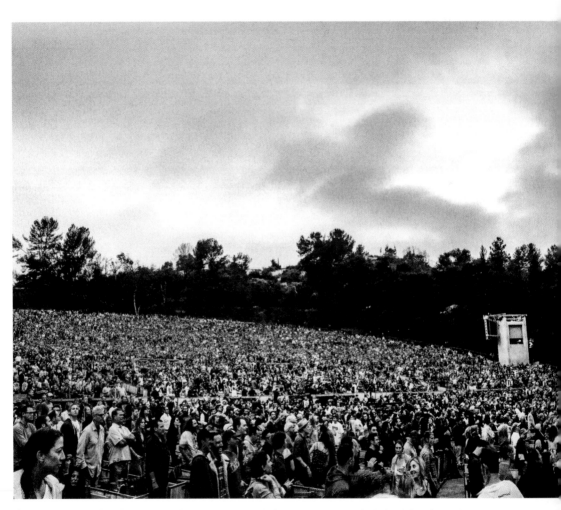

The Hollywood Bowl has been host to the world's greatest music talent for decades. It's an outdoor amphitheater nestled at the foot of the Hollywood Hills.

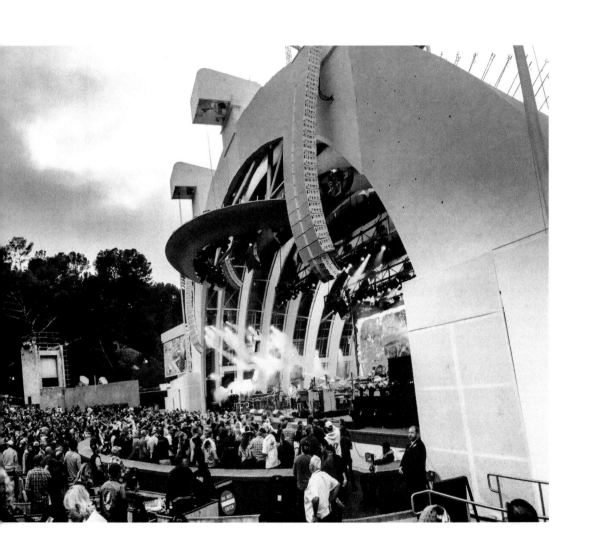

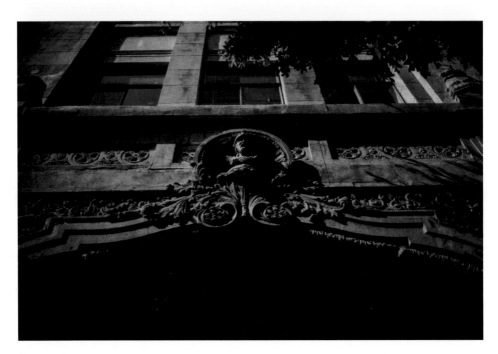

An ornate marquee.

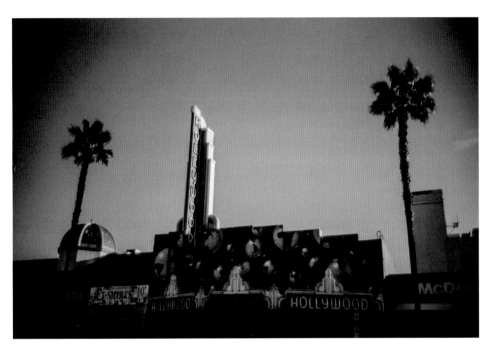

Tourist attractions now fill Hollywood Boulevard.

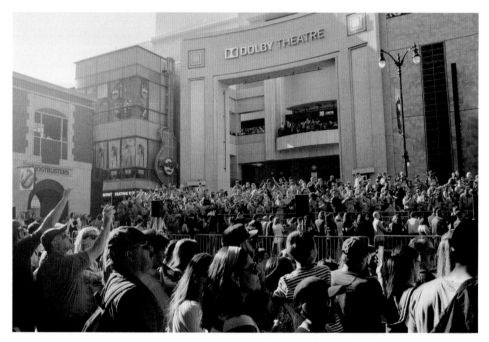

Fans waiting for their moment to catch a glimpse of their favorite stars from *Ghost-busters* at its Hollywood premiere.

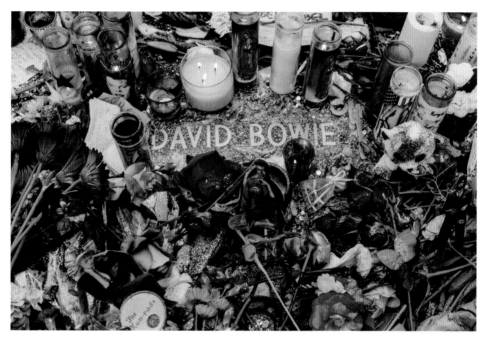

The Walk of Fame also becomes a place for fans to share their grief and remembrance when one of its stars sails off into the skies.

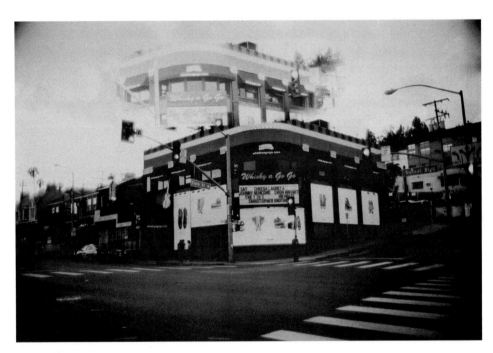

When inside the Whisky a Go Go, you can still feel the ghosts of Jim Morrison and so many others on its little barroom stage.

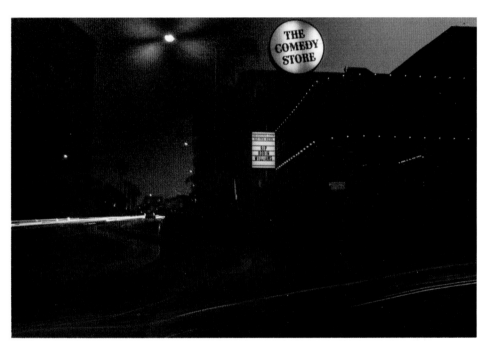

Stand-up comedy is said to be one of the hardest talents to realize. So many legendary talents, including the great Robin Williams, made their names in places like the Comedy Store. Many of us still smile at the thought of his genius.

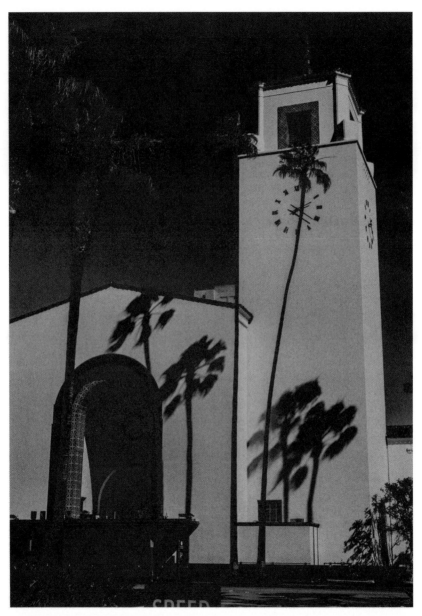

Trains arrive at Union Station with so many people coming to chase their dreams.

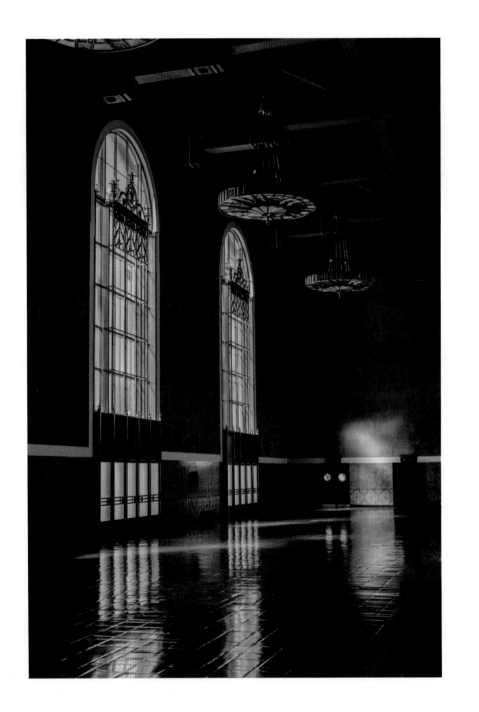

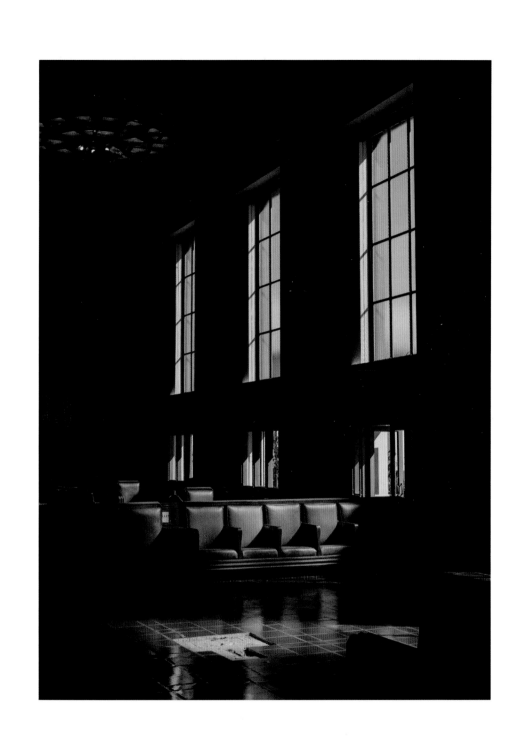

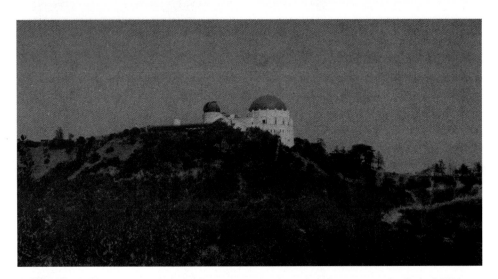

Griffith Park Observatory is best known as the location for scenes in *Rebel Without a Cause*. . . . James Dean, another talent who left us before his time.

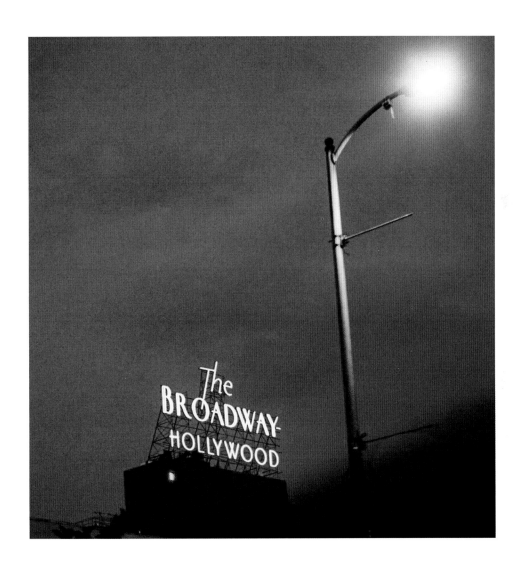

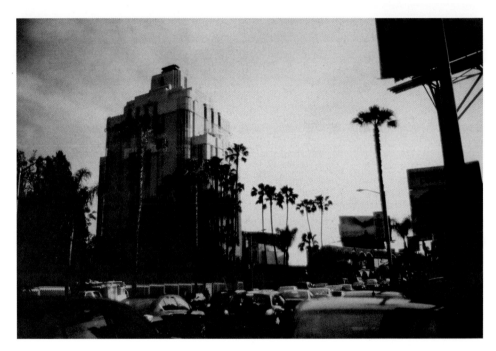

The Sunset Tower is another Art Deco landmark hotel on Sunset Boulevard. The maître d' of the hotel dining room, the Tower Bar, is Dimitri Dimitrov. He, too, is a Hollywood legend.

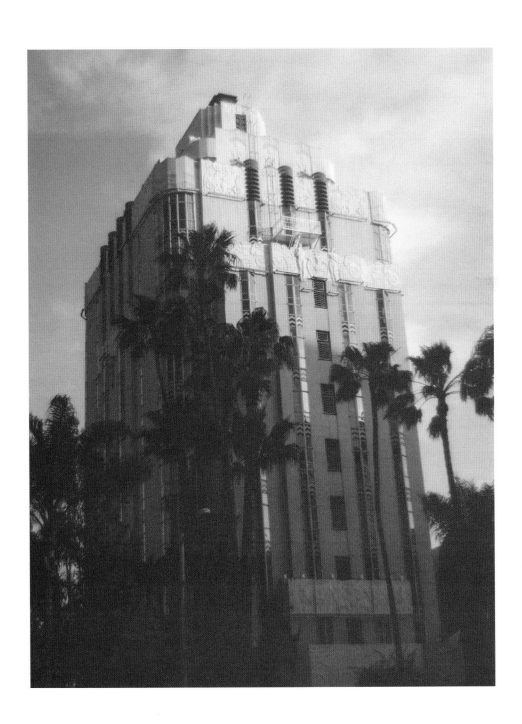

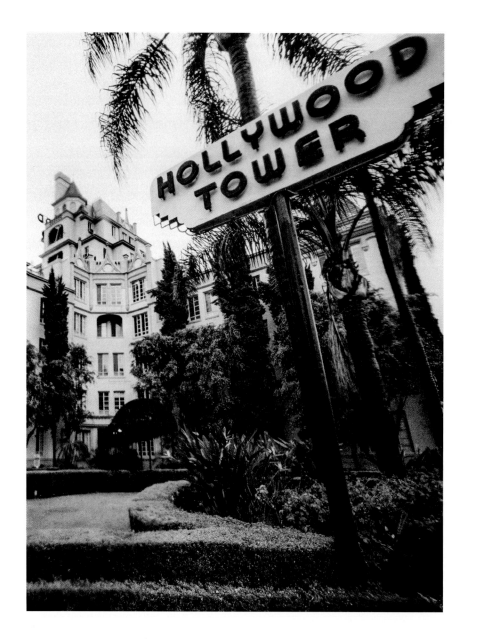

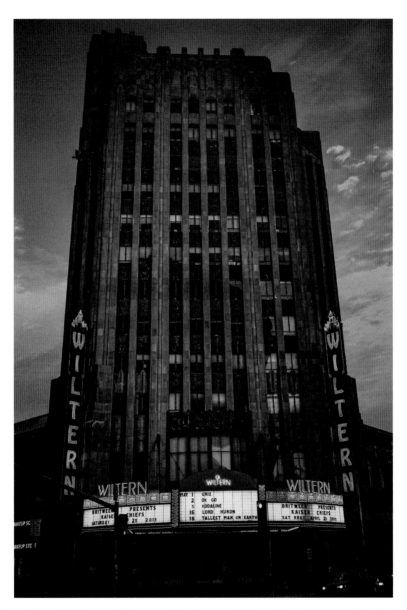

The Wiltern on Wilshire Boulevard in Hollywood is another example of Art Deco architecture and music history. The Rolling Stones performed one of their famous small-venue shows in this gem.

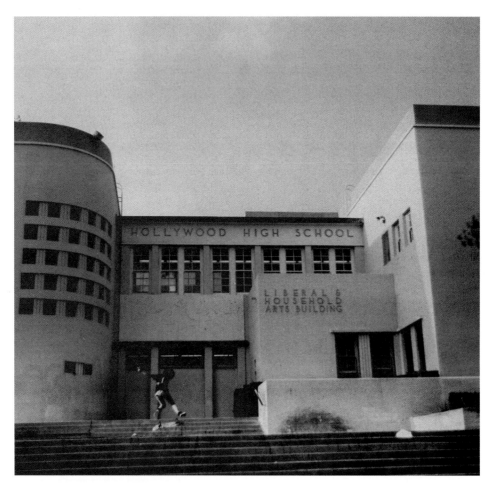

Judy Garland is an early alumna.

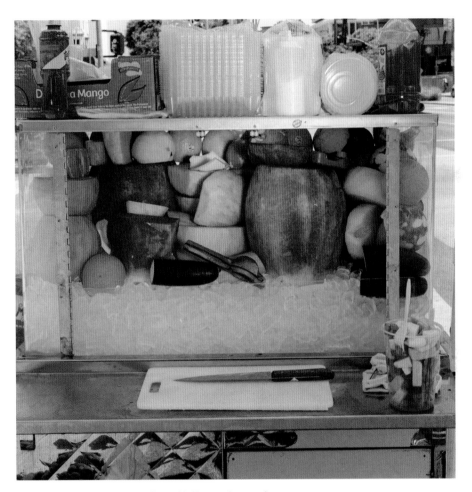

Street vendors are part of the Hollywood mosaic.

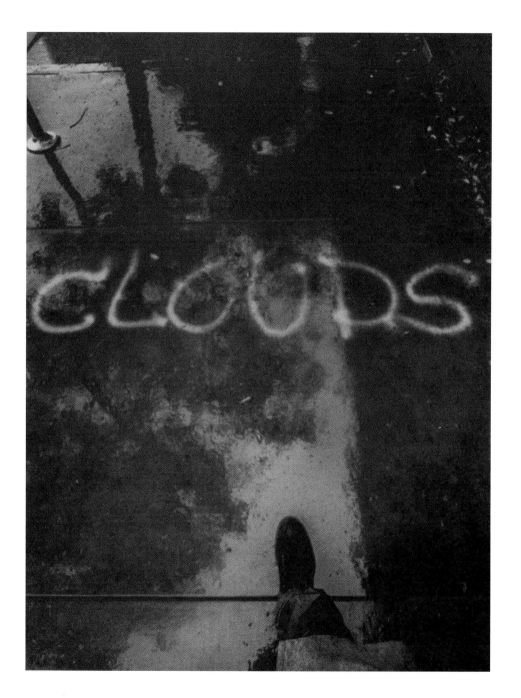

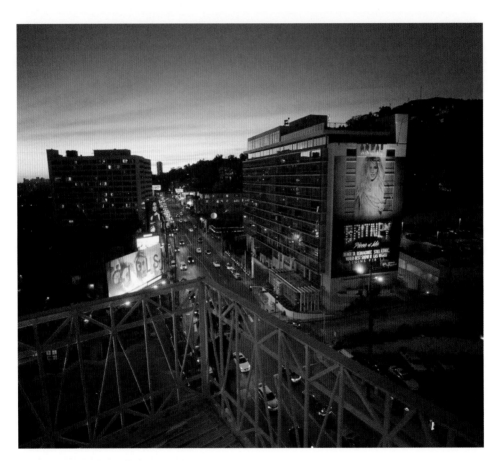

The famous Sunset Strip at night.

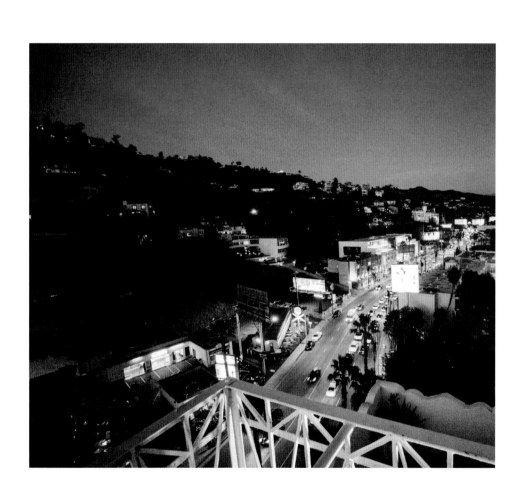

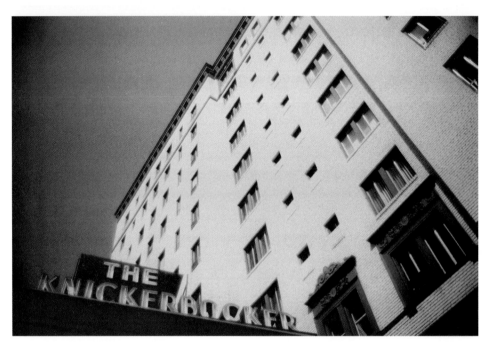

Marilyn Monroe and Joe DiMaggio started many evenings at the bar in the Knickerbocker.

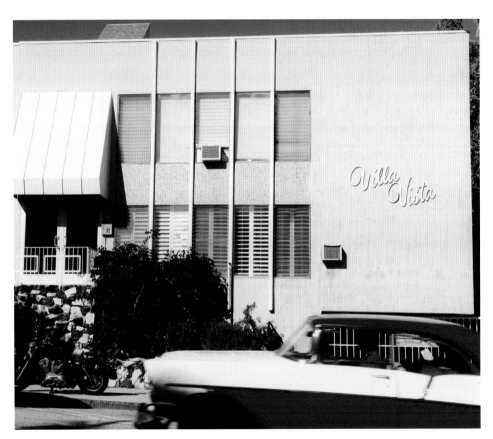

A slice of the Hollywood neighborhood.

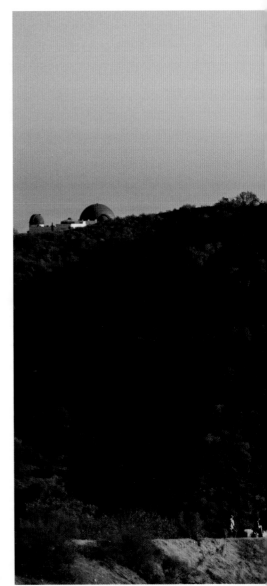

The city in the hills.

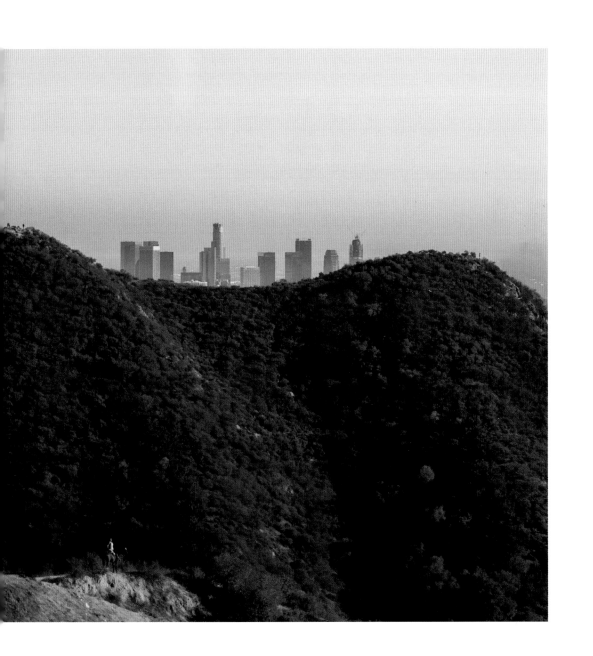

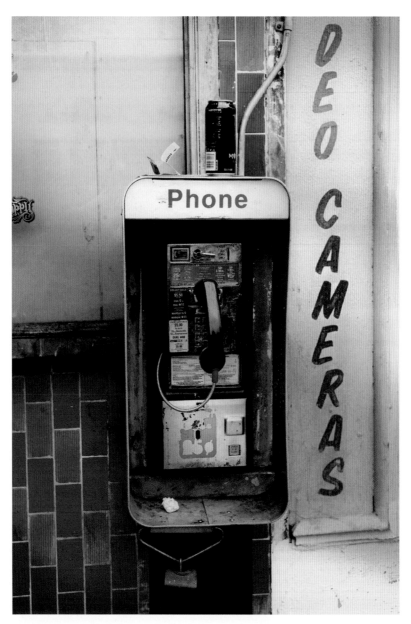

These are very rare specimens of what were once known in modern culture as pay phones.

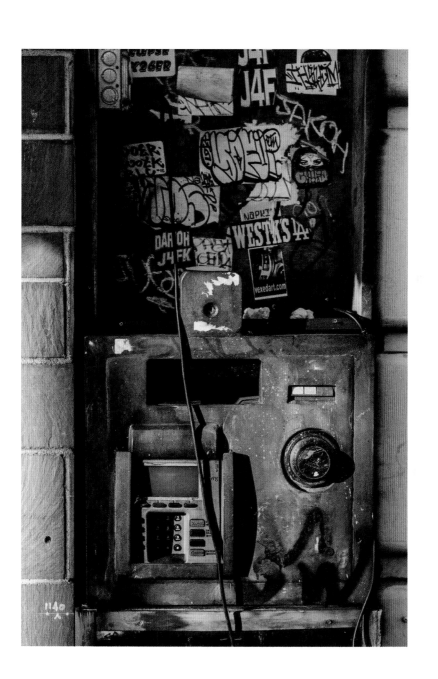

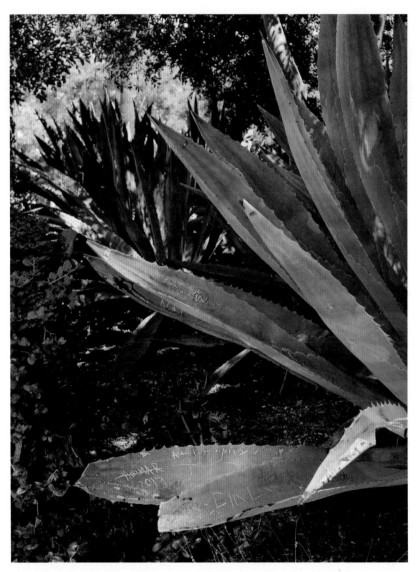

Even the plants aren't safe from poetic expression.

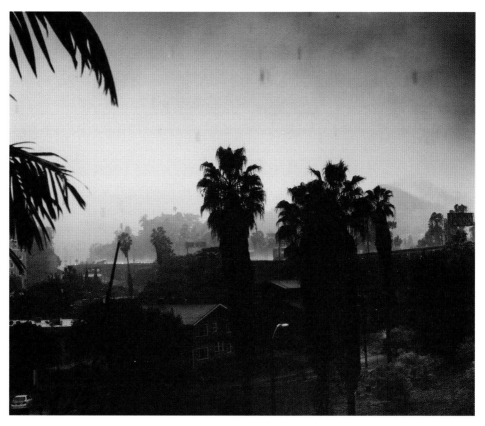

Rare and almost unique: the Hollywood downpour.

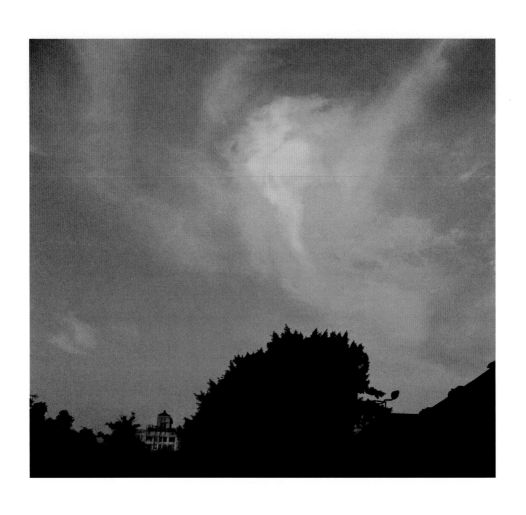

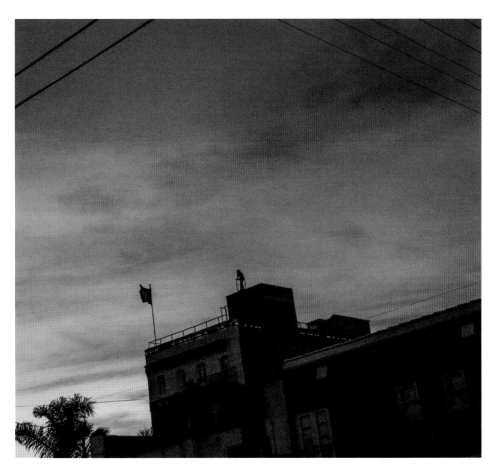

All under peaceful skies.

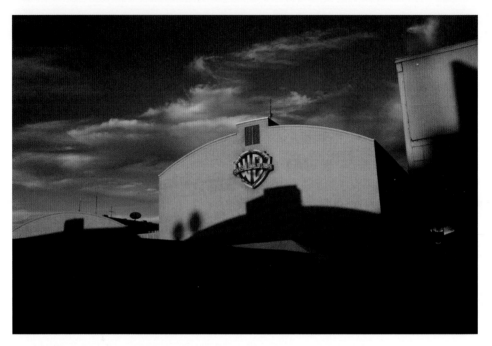

Founded by Albert, Harry, Sam, and Jack Warner . . . the studio has entertained generations with its production magic.

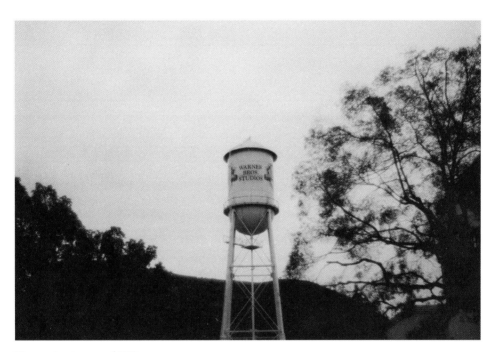

The water tower of WB.

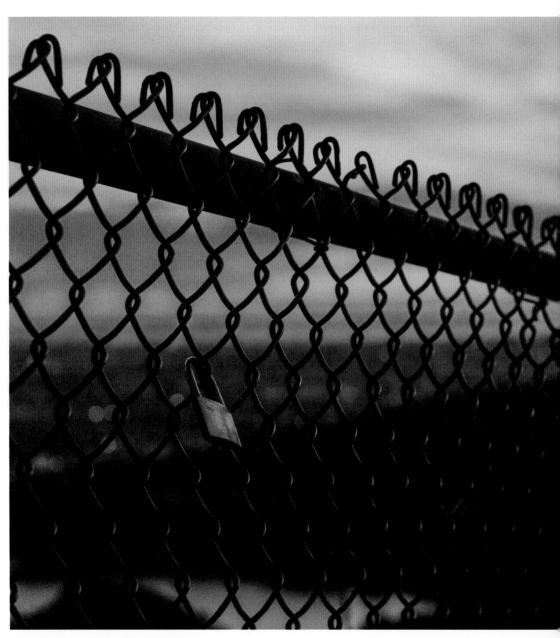

Locked out of the Hollywood Sign.

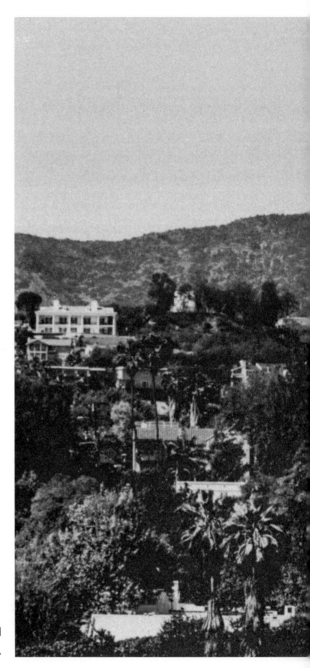

Hollywood has long been a place for social
expression and in this case . . . vandalism.

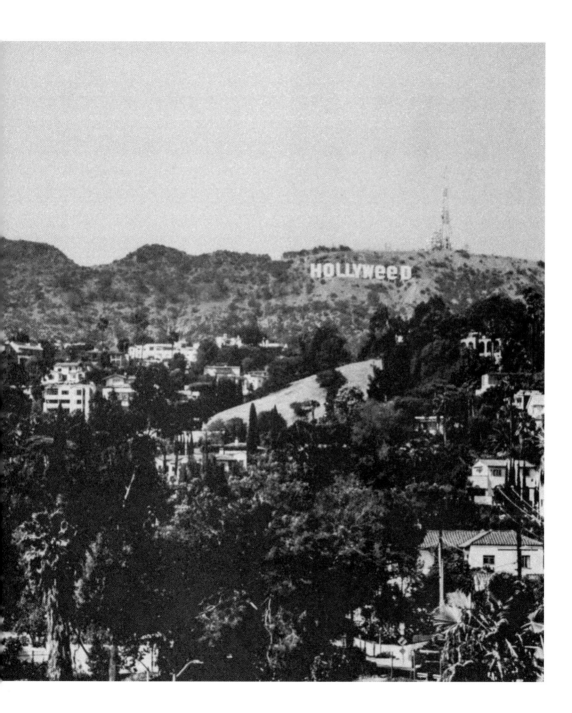

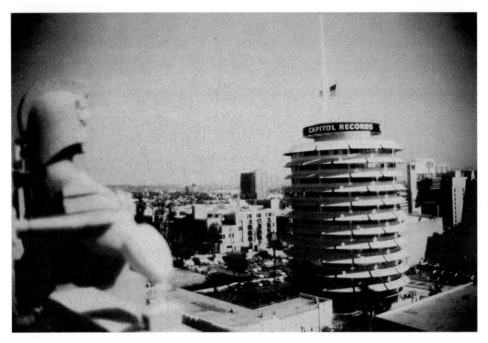

Studio A, the main recording studio in Capitol Records, has been ground zero for so much music, it's impossible to list all of it. Images of Frank Sinatra in a suit and tie come to mind.

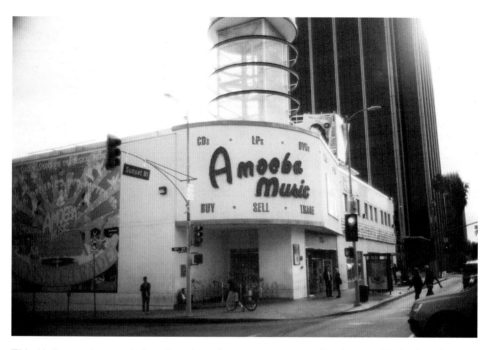

This Hollywood record store has long been a must stop for those still digging for that special record they don't yet have in their collection.

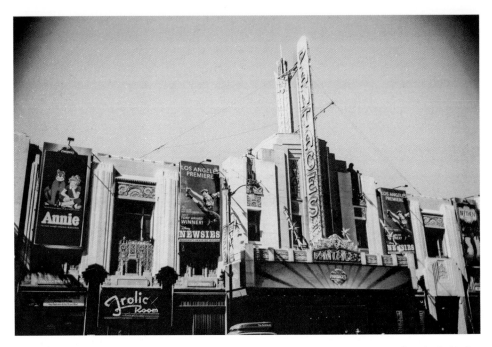

Another Deco shrine, home to major Broadway musicals that come for their Hollywood runs.

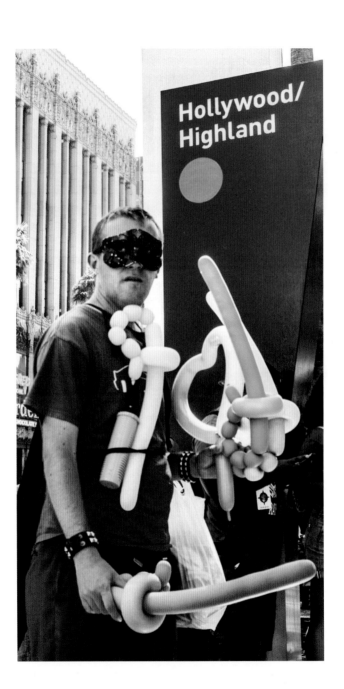

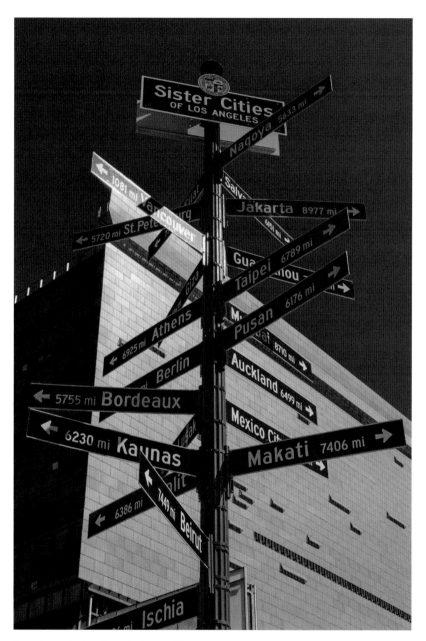

Do all roads lead to Hollywood?

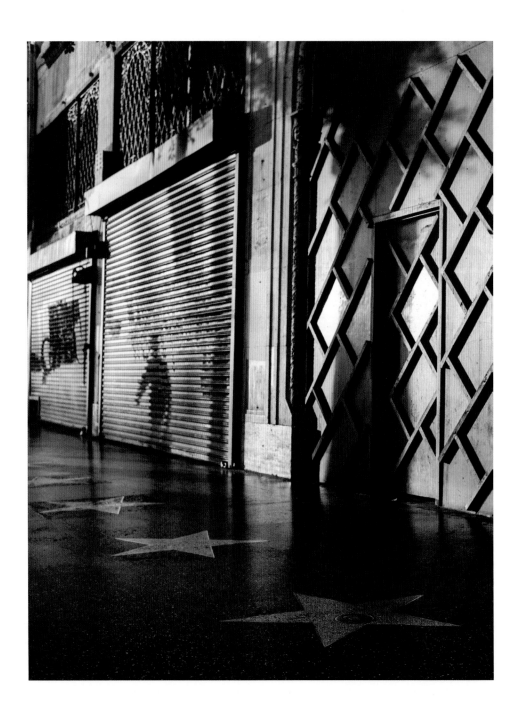

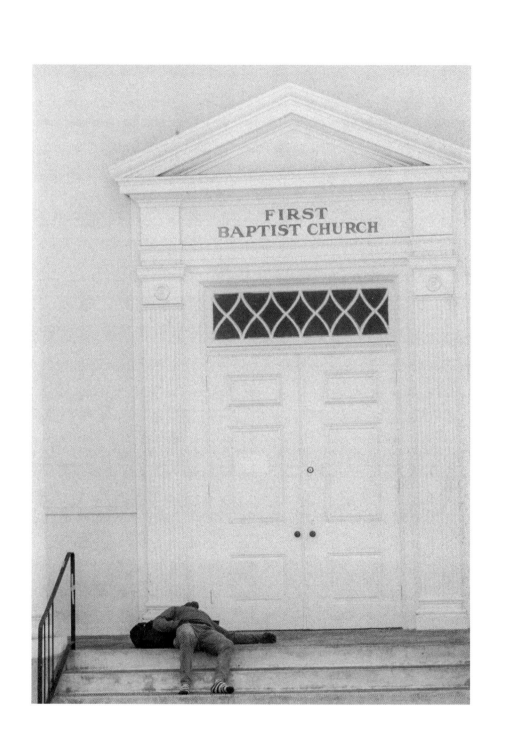

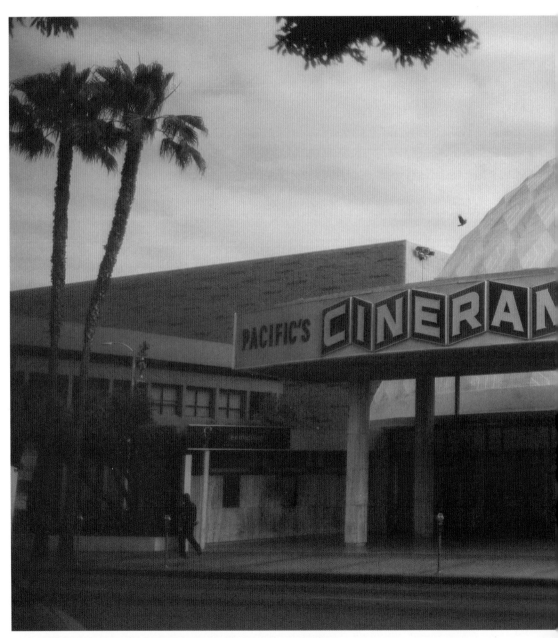

On a premiere night, it looks like ants trying to lift a golf ball.

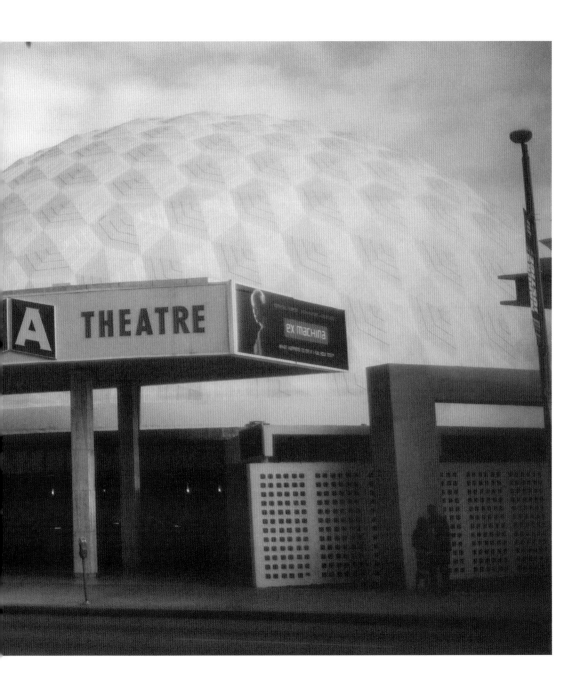

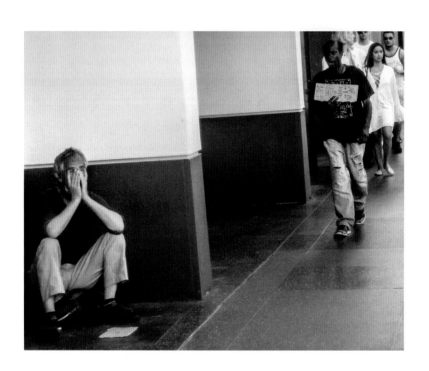

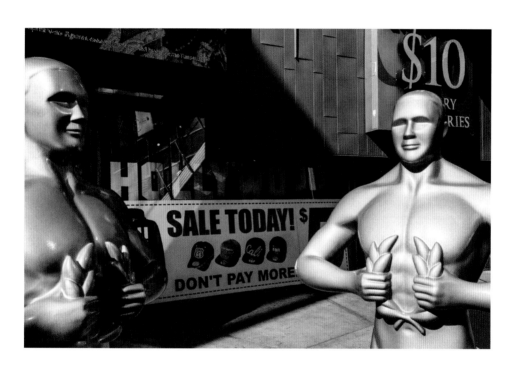

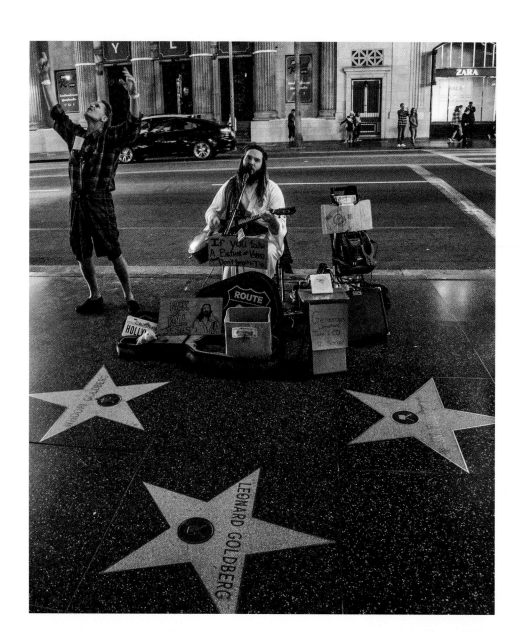

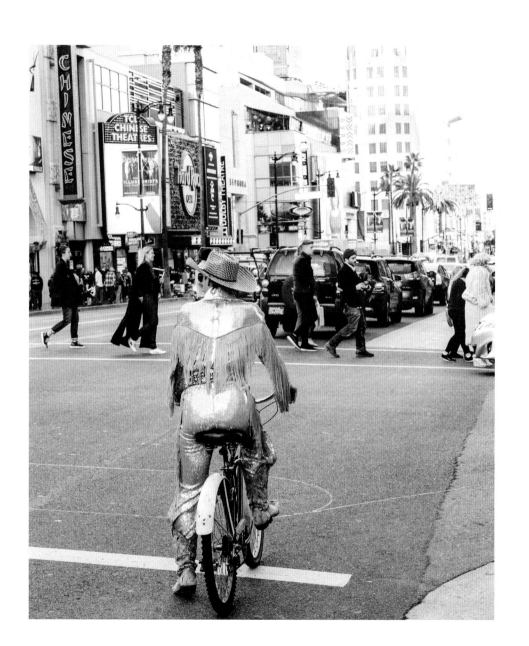

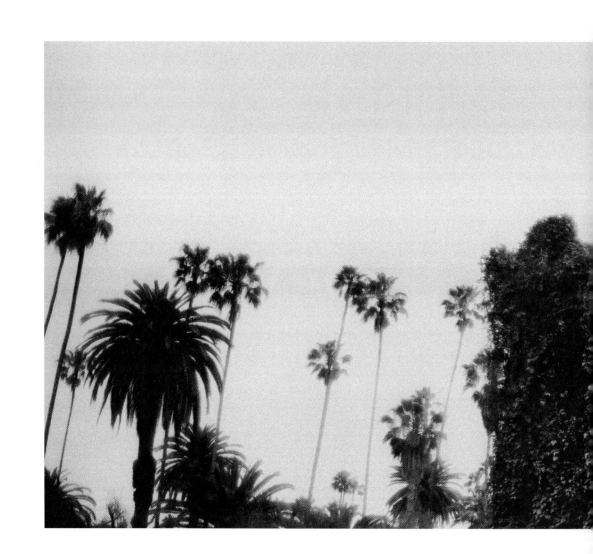

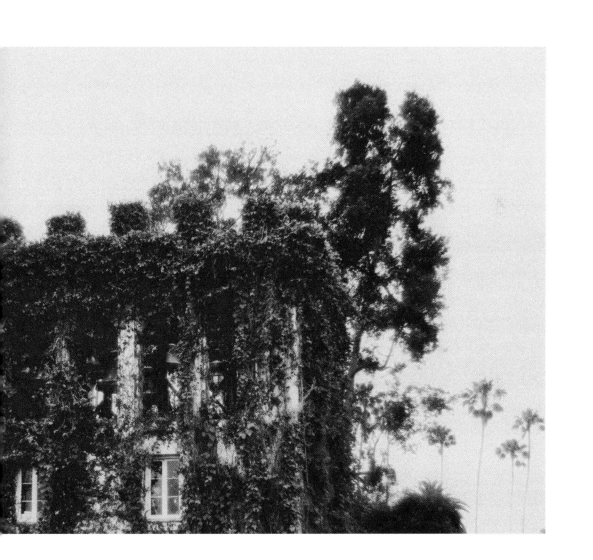

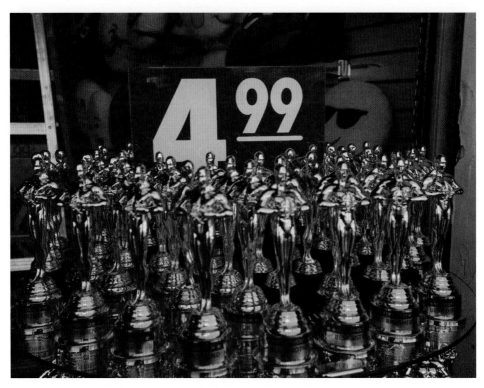

For everyone, or anything.

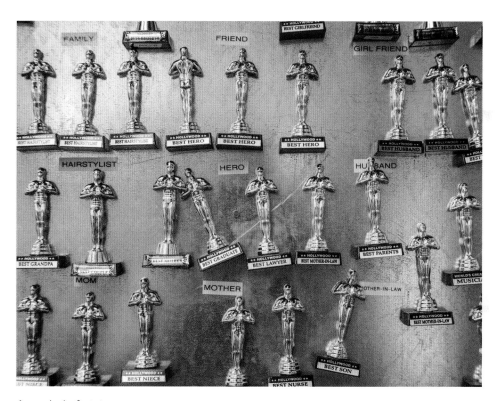

A symbol of status.

Parking in Hollywood can be a nightmare.

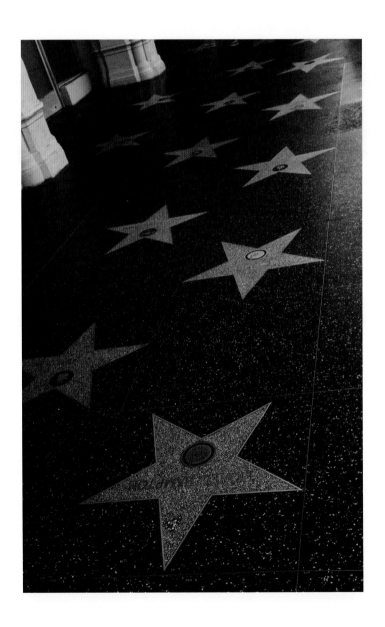

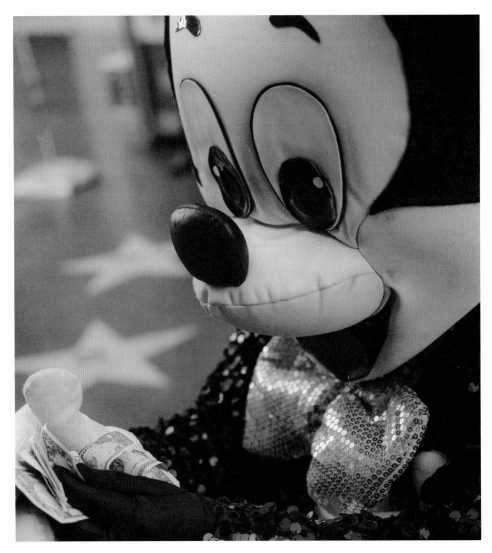

Mouse. Cash.

HOLLYWOOD MIMICS LIFE, BOTH ON AND OFF THE SCREEN.

We stumble, we triumph.

We people-watch to gain little bits of our own self-awareness.

We learn . . . what's cool, who's not, and why we care.

Do you?

Do you notice the people around you, vibrating with excitement to be where they stand?

Do you see the ones in the edges of the light who have lost anything or everything?

All of these lives separated by a few changes. Not so different anymore.

We are all free to dream. However bright and however dark, we embark upon the never-ending hopes of this foreverland.

This next section is a photo examination of immortalized Hollywood legends. Using my portrait shots from Madame Tussauds Wax Museum, I have juxtaposed them with street performers, tourists, public figures and celebrities.

To maintain anonymity, the stories have no relation to any photos surrounding them. Somehow, in Hollywood, we all live together.

What is real and what is not will always be debated here. . . . You decide.

Sometimes I think I am losing my mind, but then I remember . . . I'm just in Hollywood.

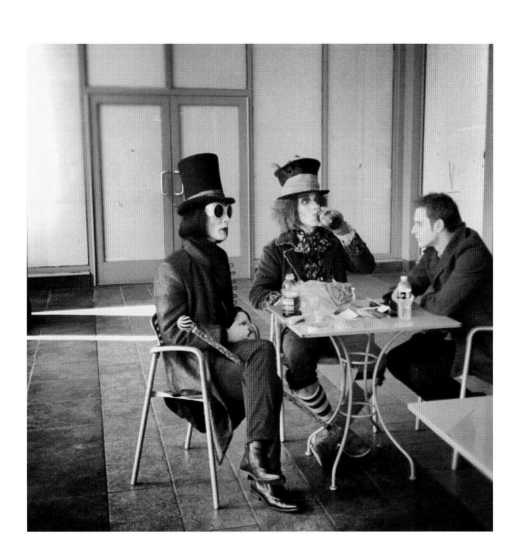

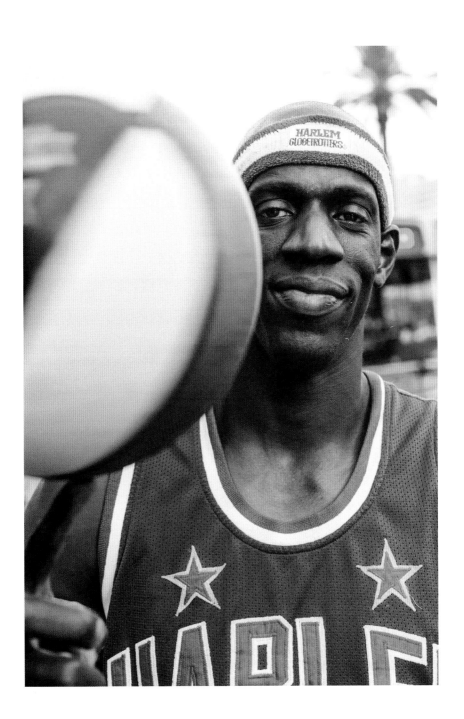

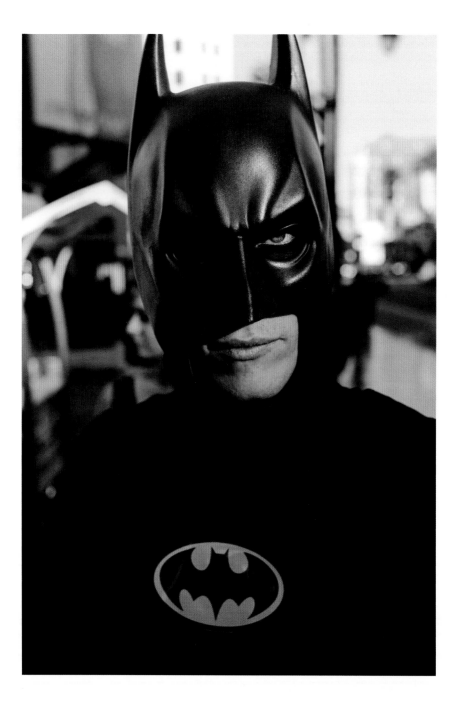

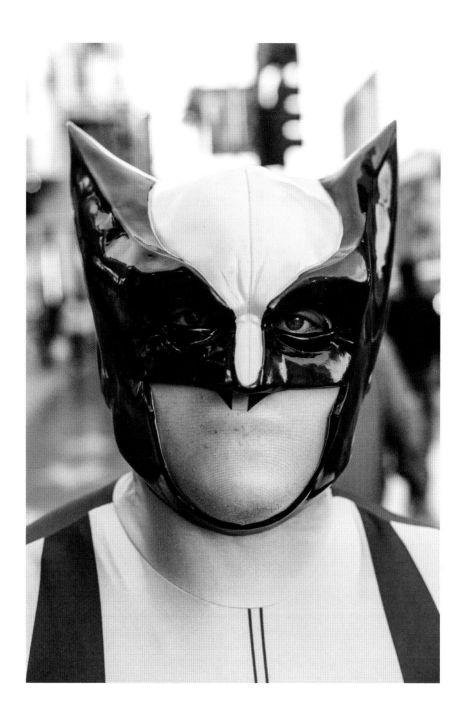

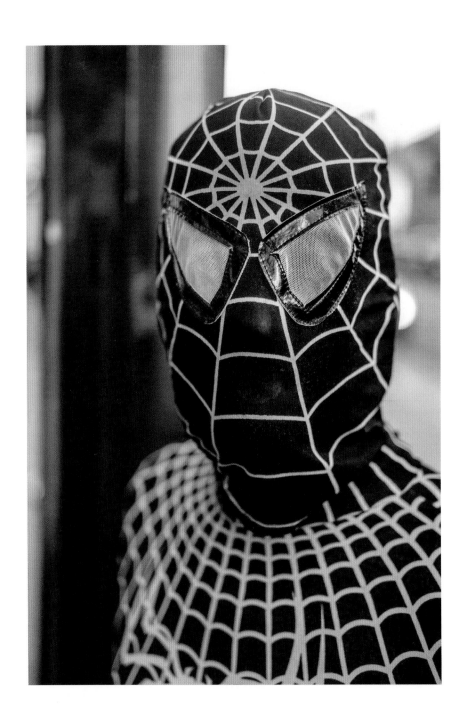

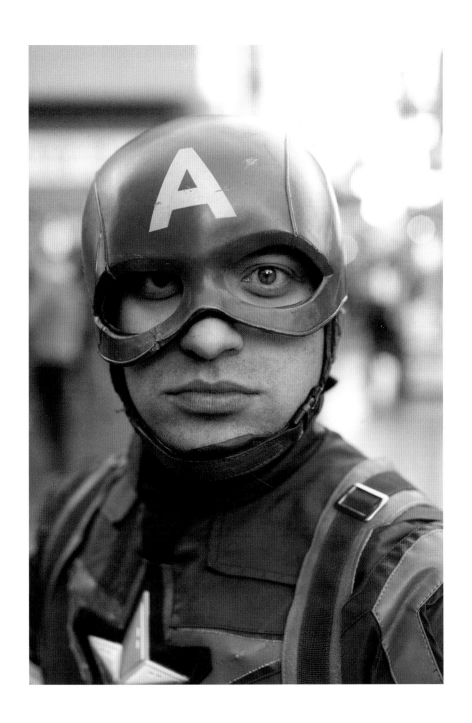

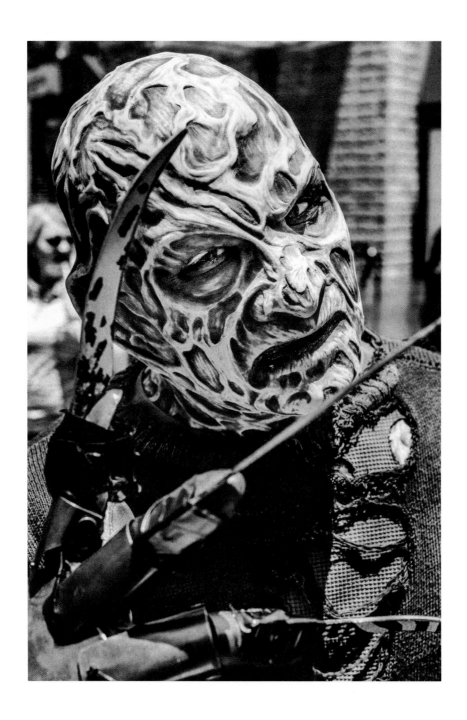

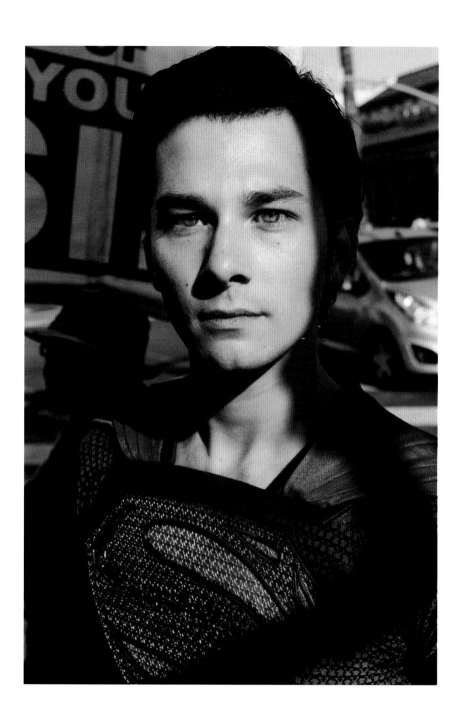

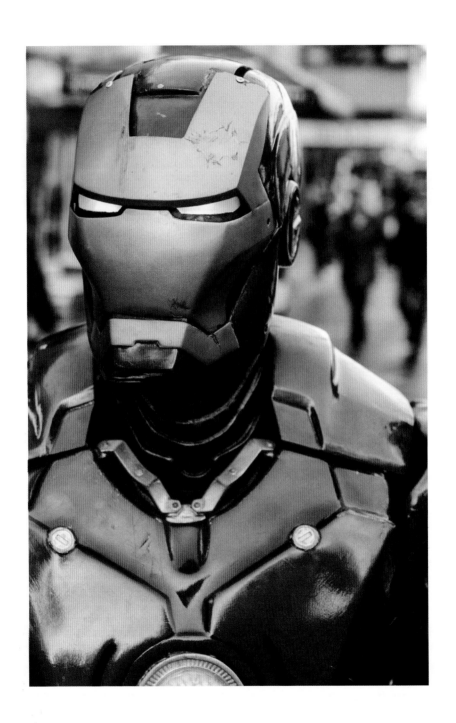

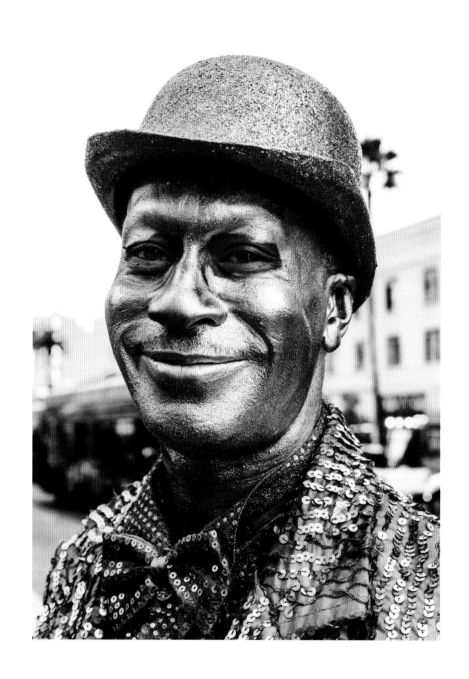

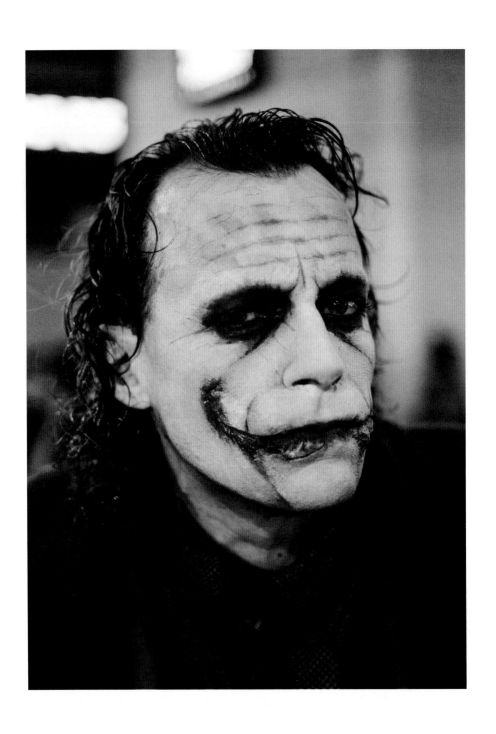

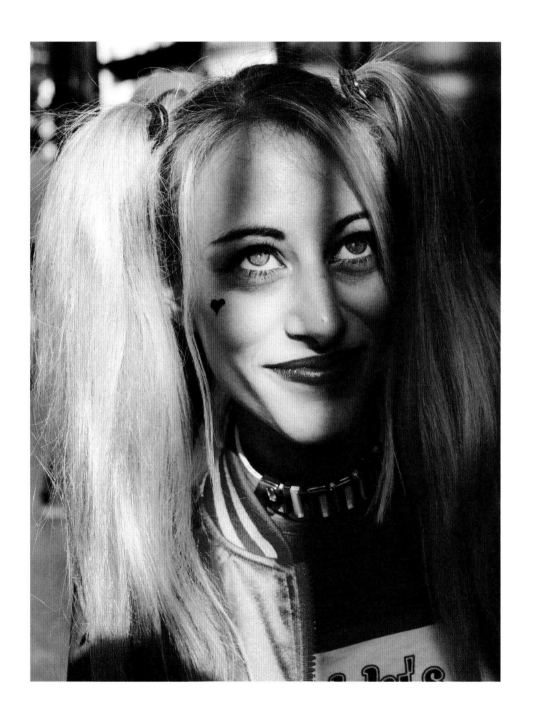

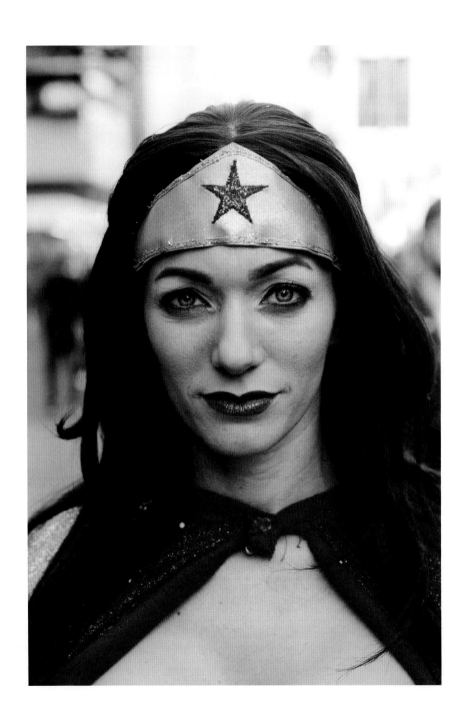

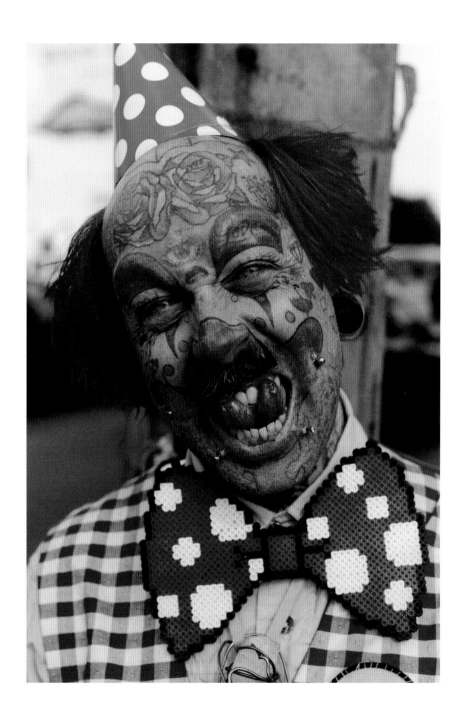

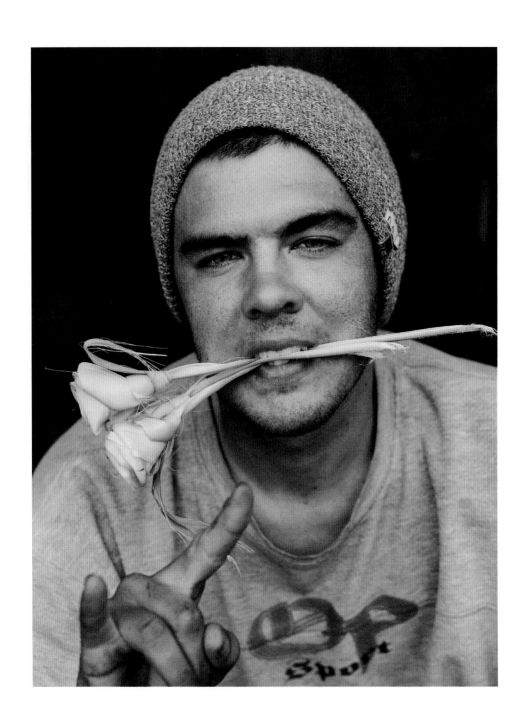

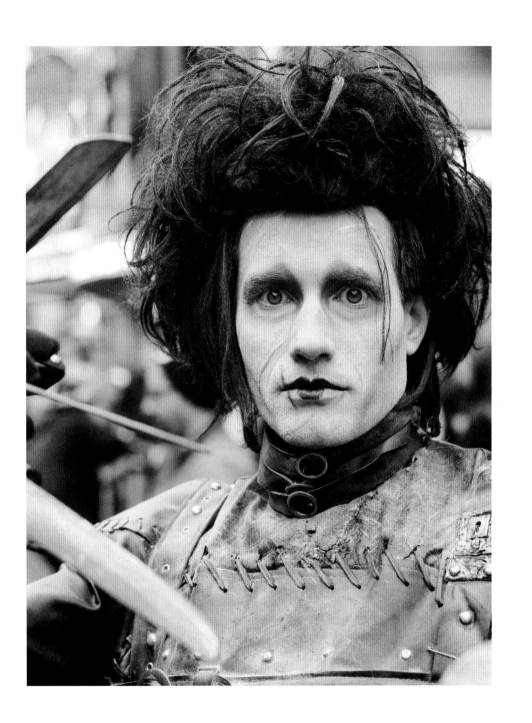

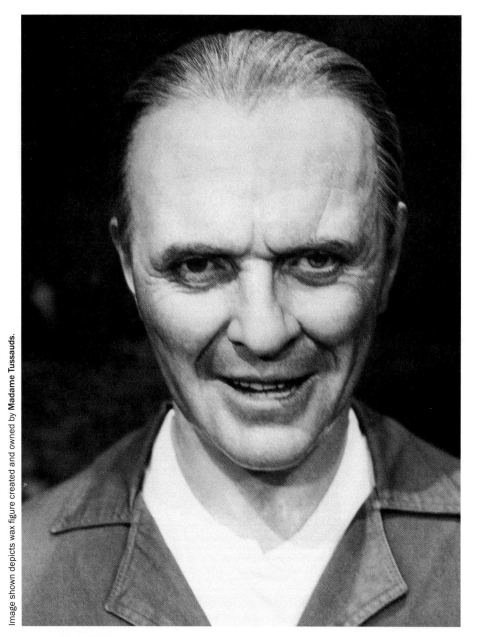

Anthony Hopkins
Forever immortalized.

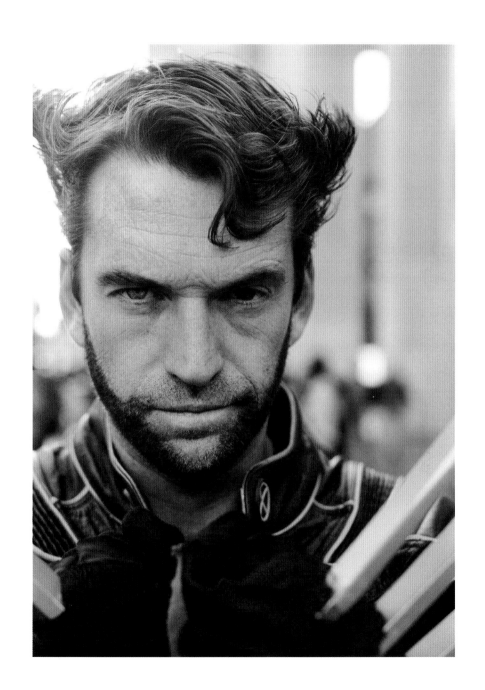

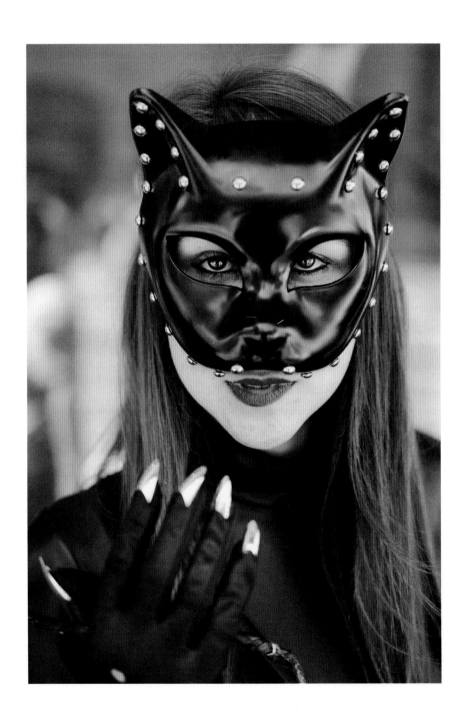

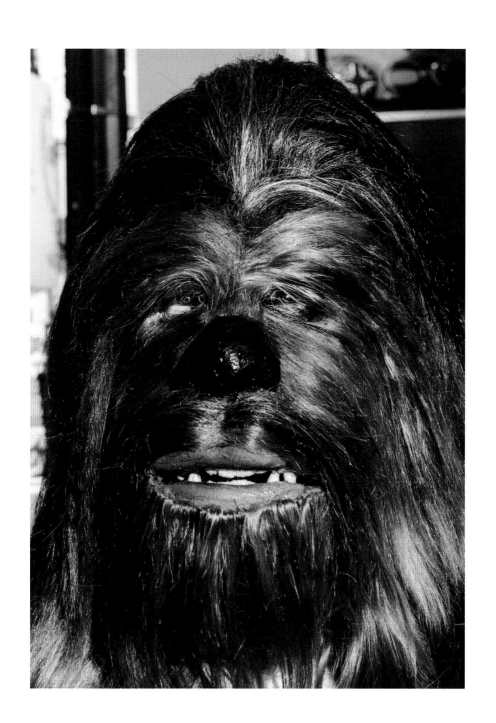

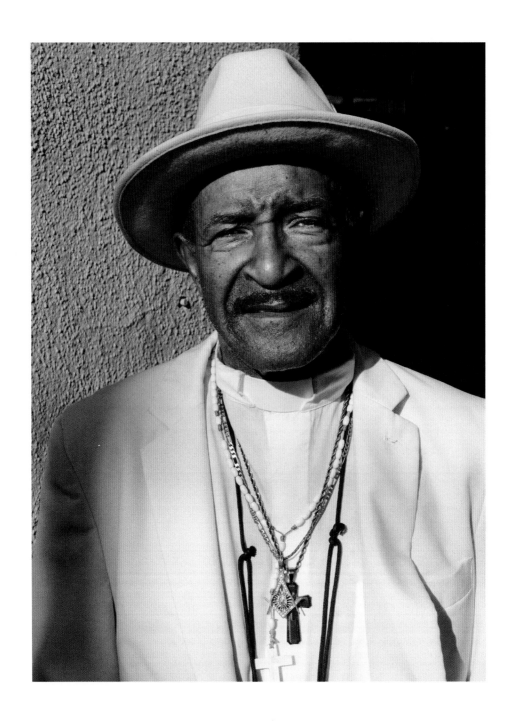

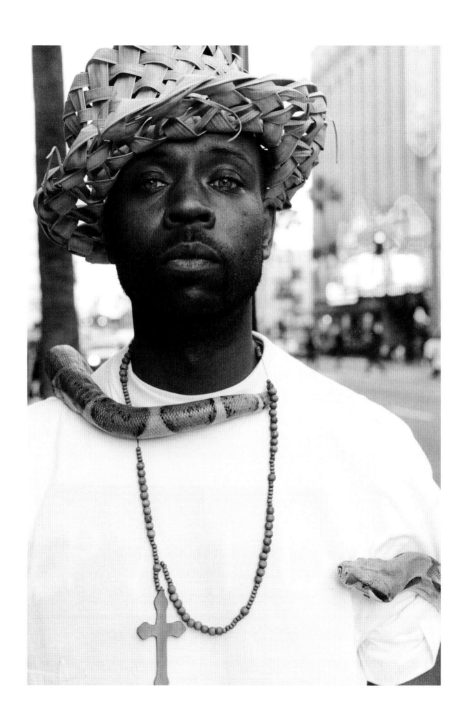

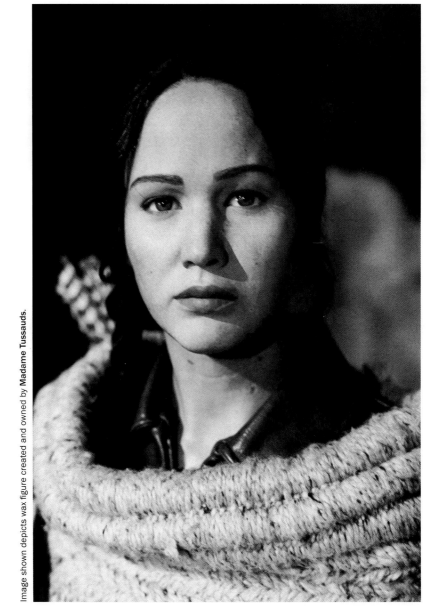

Jennifer Lawrence
Forever immortalized.

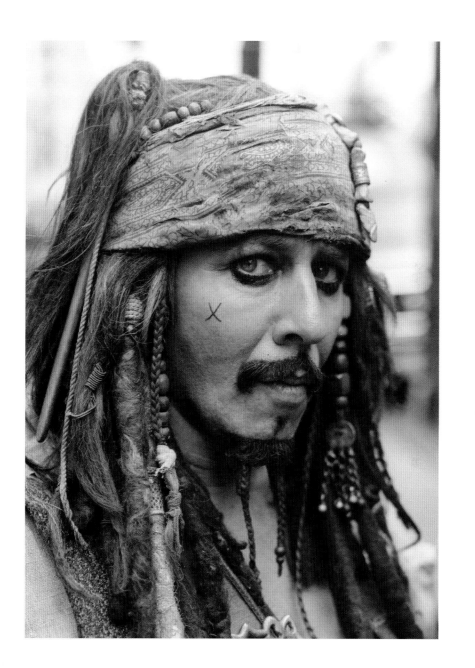

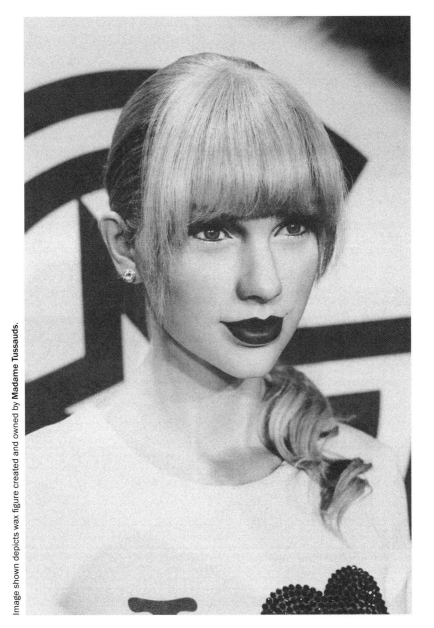

The old Taylor
Forever immortalized.

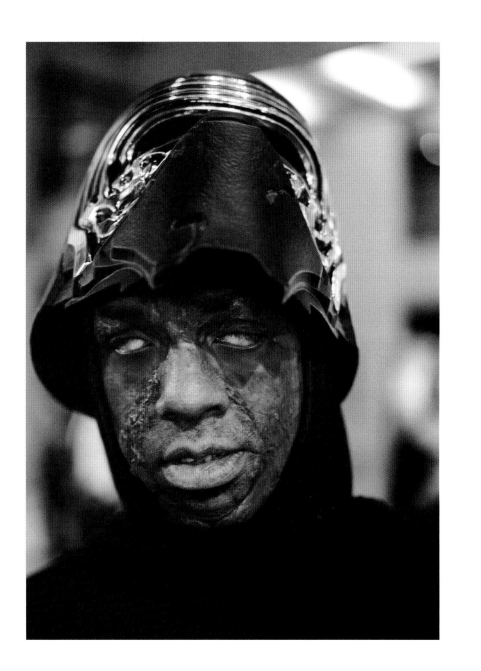

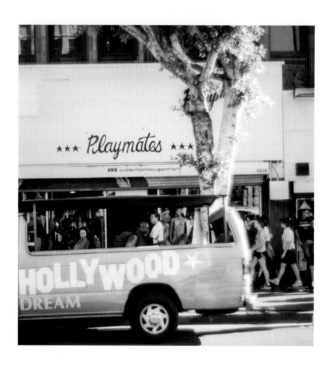

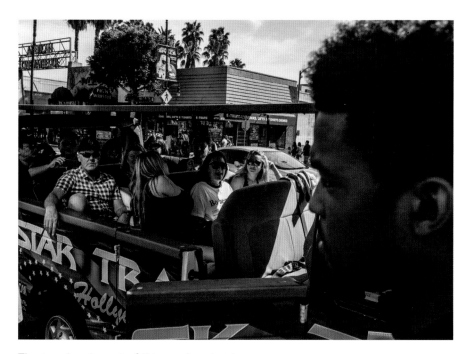

The tour bus is part of this modern landscape.

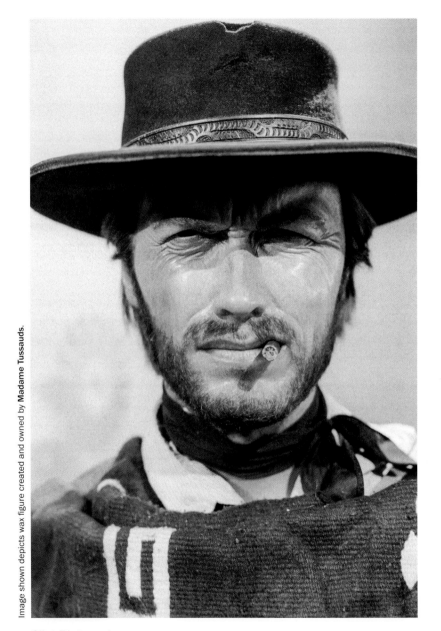

Clint Eastwood
Forever immortalized.

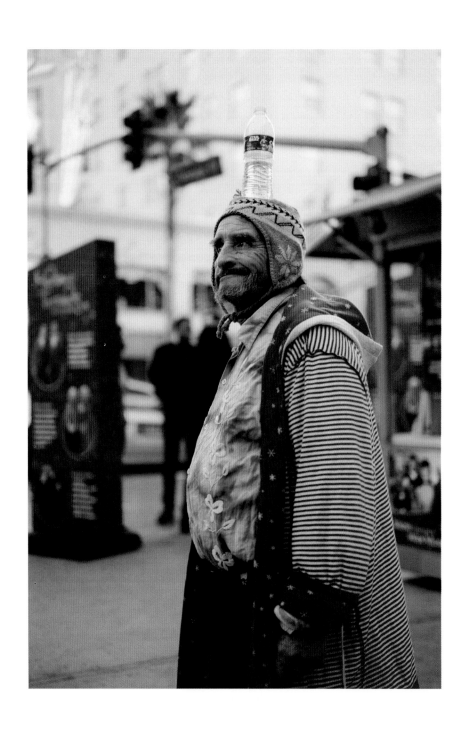

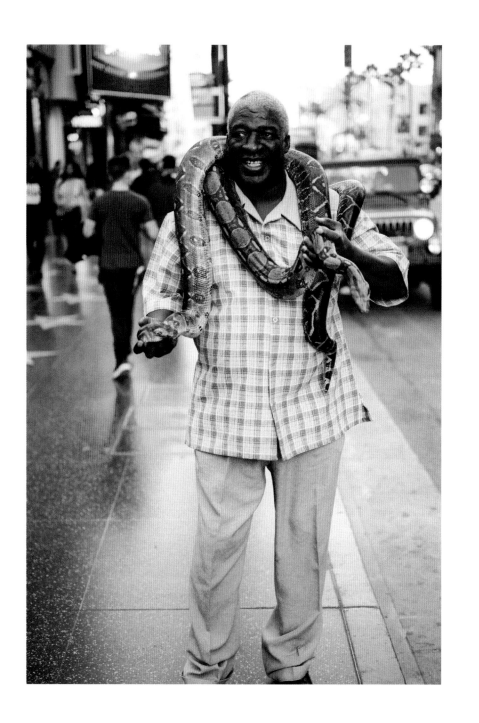

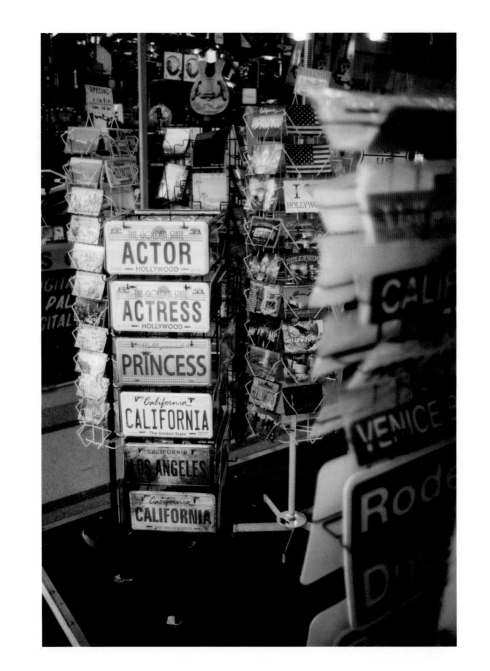

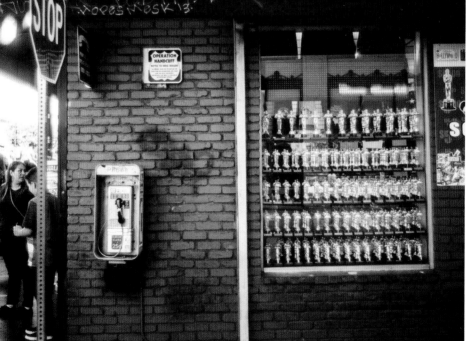

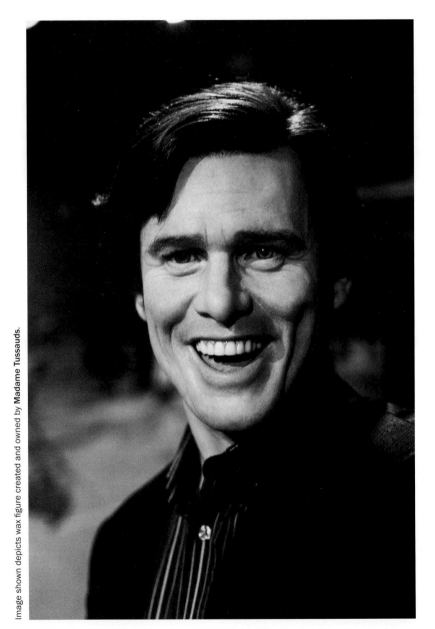

Jim Carrey
Forever immortalized.

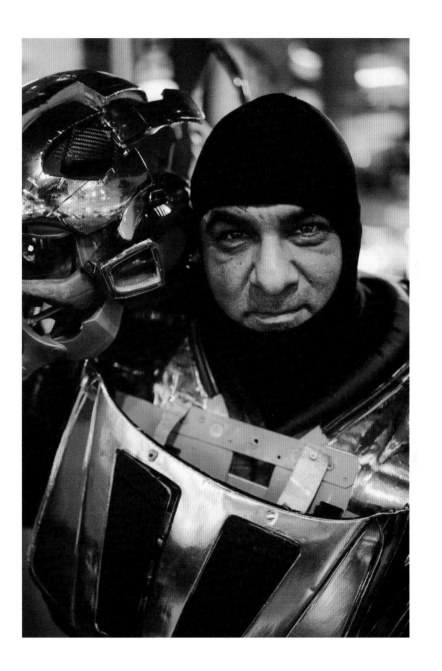

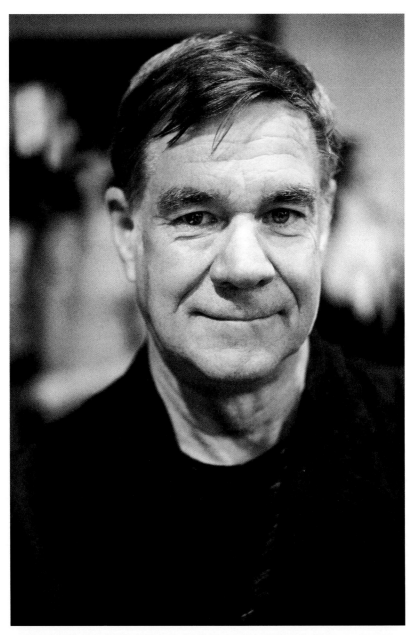

Gus Van Sant, the well-known filmmaker and photographer.

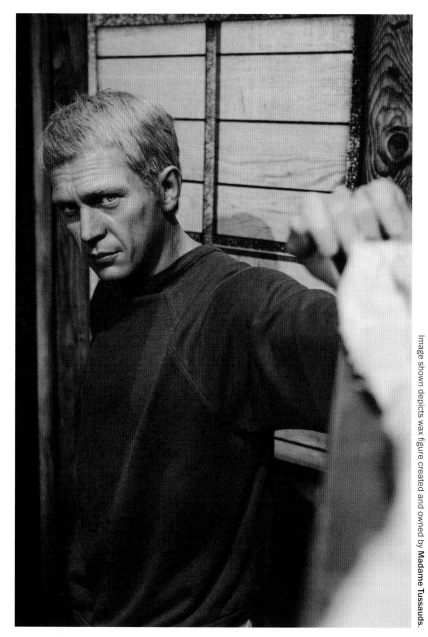

Steve McQueen, the regularly photographed.
Forever immortalized.

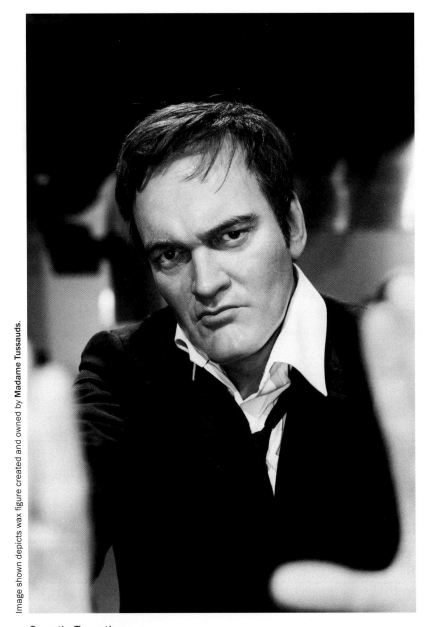

Quentin Tarantino
Forever immortalized.

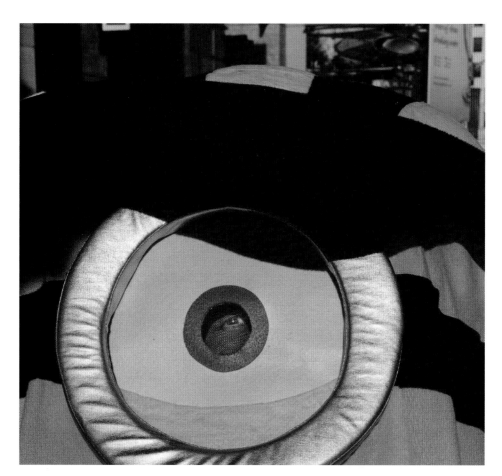

In the eye of a minion.

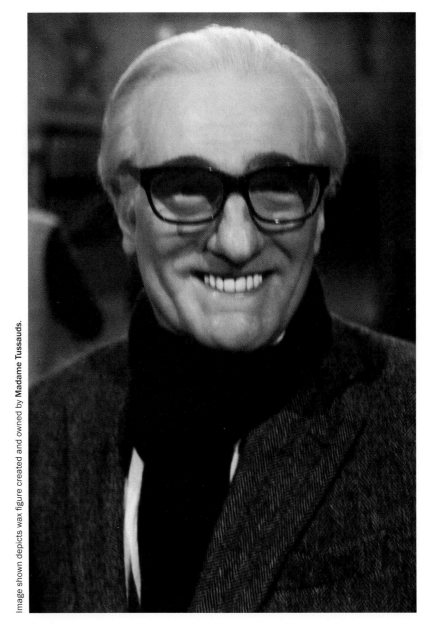

Scorsese

Forever immortalized.

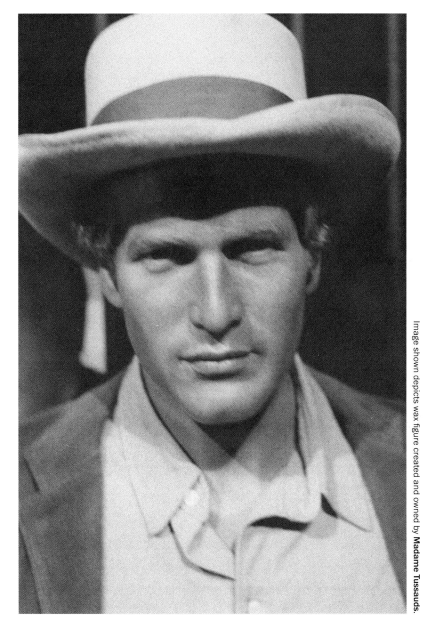

Paul Newman
Forever immortalized.

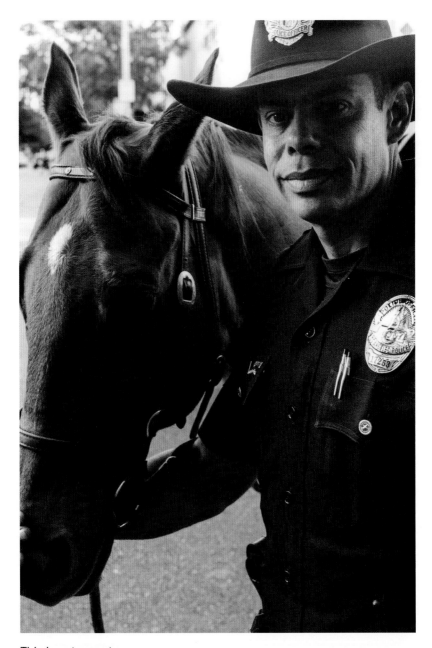

This is not an actor.

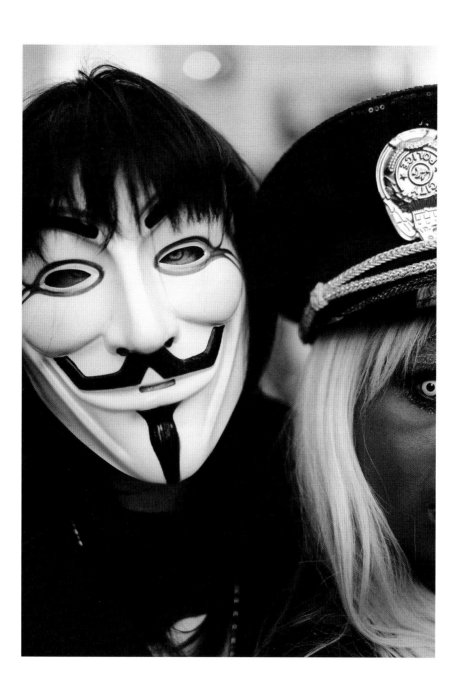

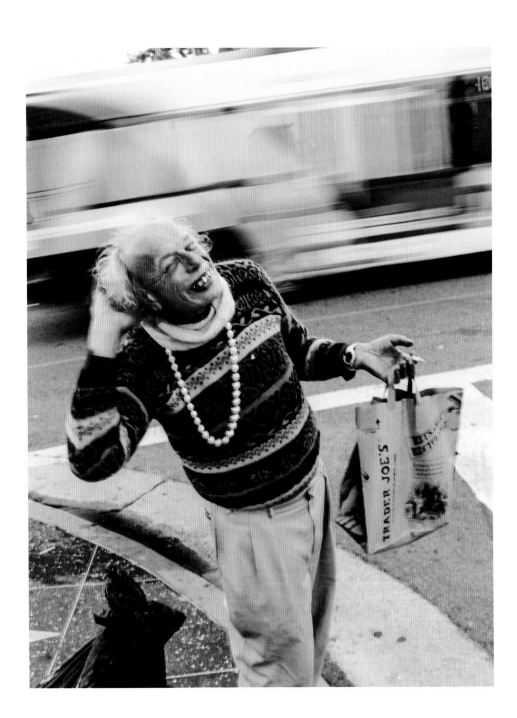

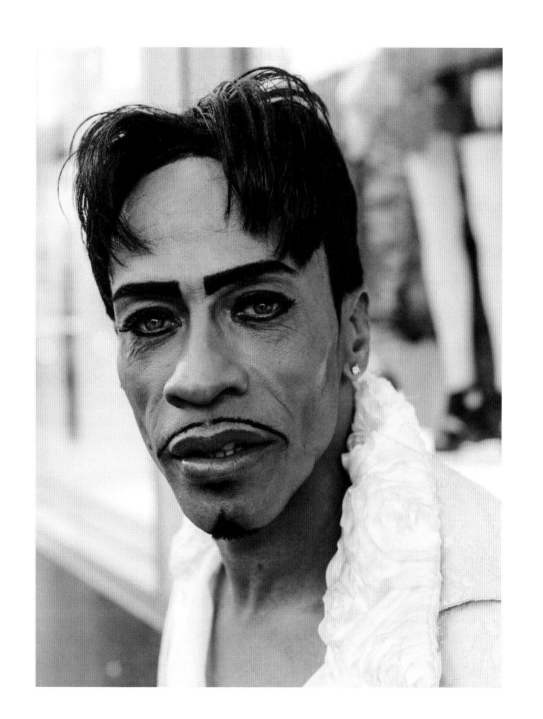

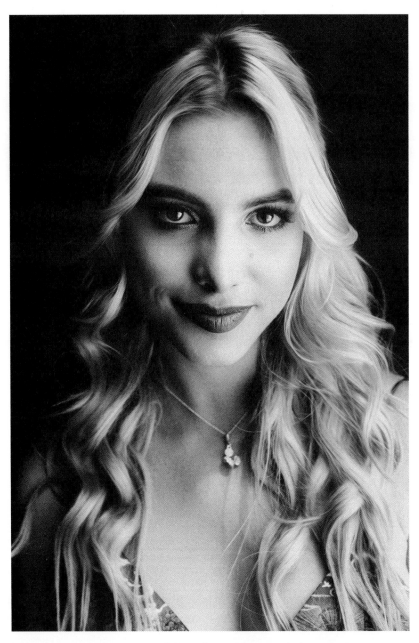

Lele Pons started out on social media and has made her way here.

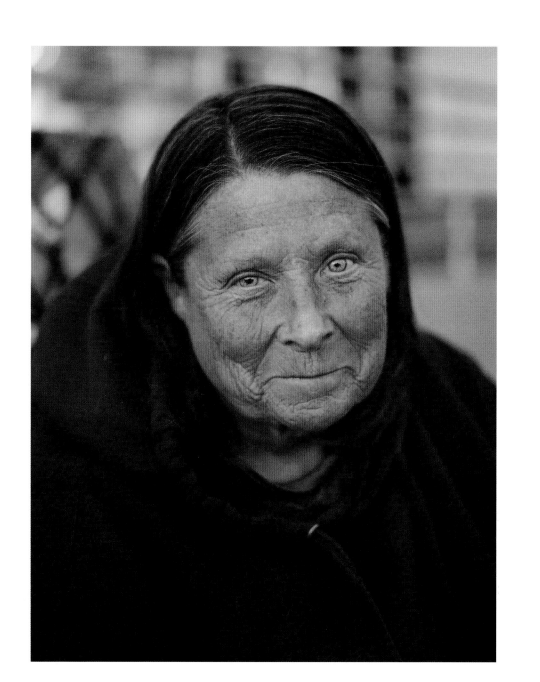

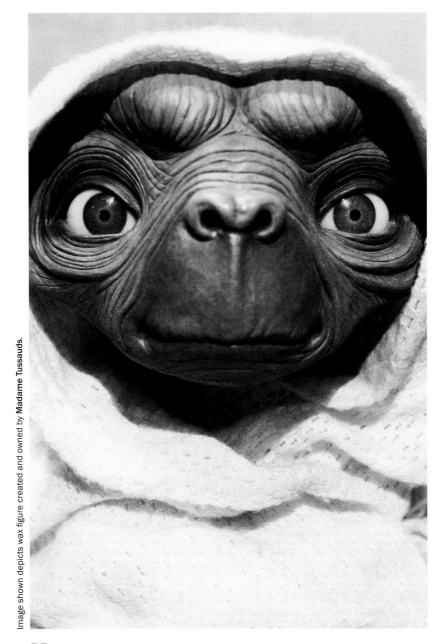

E.T.
Forever immortalized.

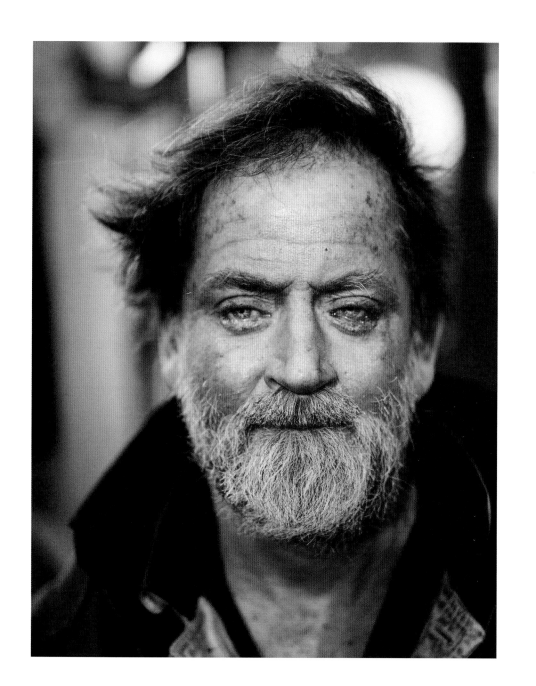

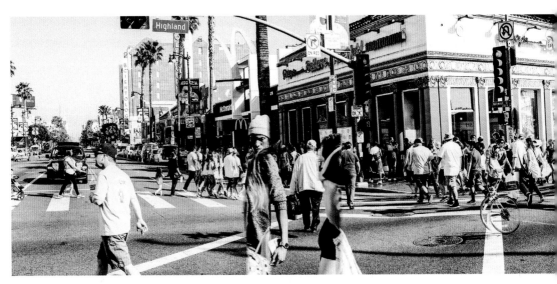

Stitched panorama of the dead center of the Hollywood and Highland intersection.

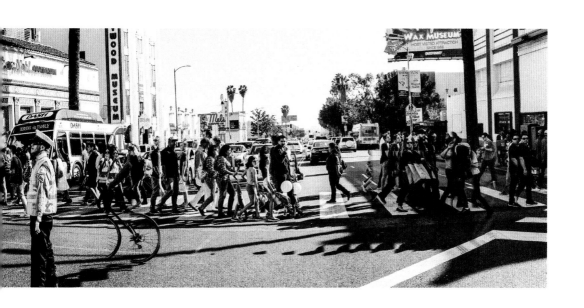

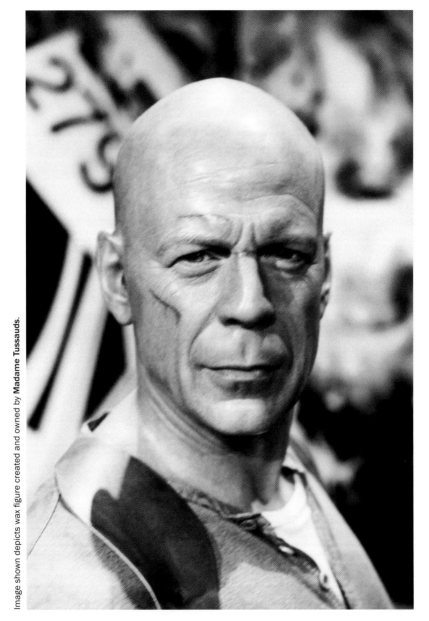

Bruce Willis
Forever immortalized.

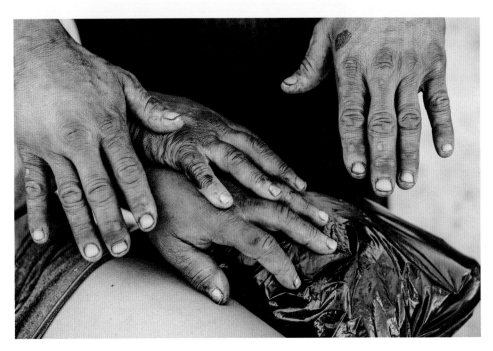

Hands down.

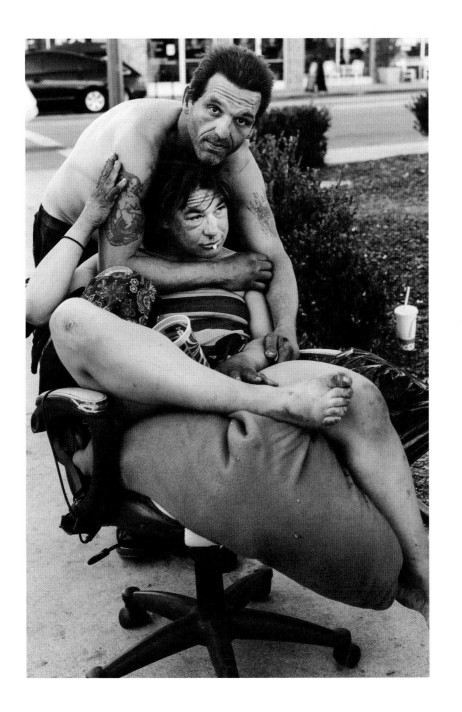

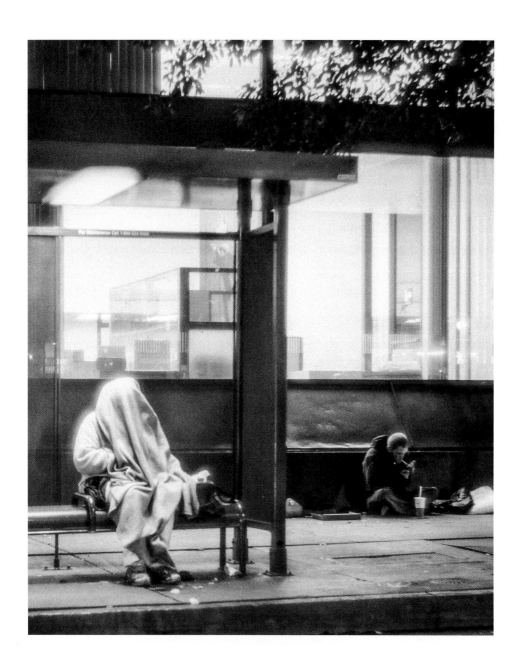

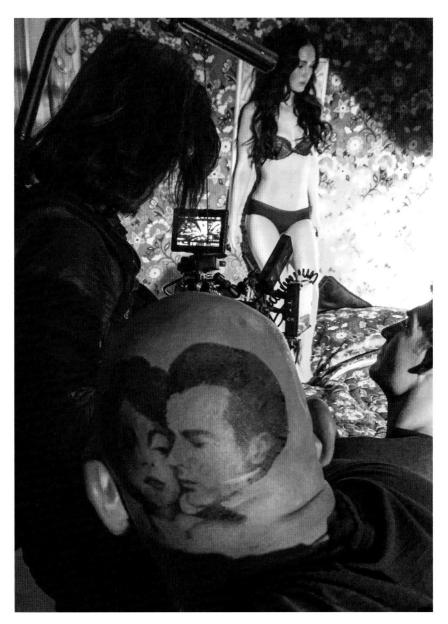

The back of James Franco's shaved and tattooed head as he directs Megan Fox in a scene for *Zeroville*.

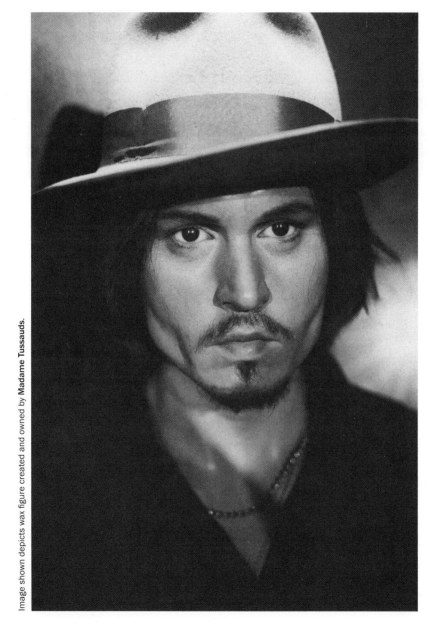

Johnny Depp
Forever immortalized.

Life imitates art.

WE ARE ALL TOURISTS AMID DIMLY LIT STARS

Is it a combination of the infinite possibilities that can happen in this town, or the unrealized fate of everyone who purchases time here?

Being lost is a trick that our souls long for our minds to explain.

This harbor of broken people walking around each other, failing to make eye contact, has only just begun to wake you up as you inch around with eyes focused on the stars in the sidewalk.

We make a checklist:

What are you searching for?

What are you running from?

What are your dreams?

Why are they so perfect?

What are others' dreams?

Why are they not perfect?

All the while, we're wrapped up in red carpets and millions of Instagram followers.

A ghostly arm rubbing our backs and asking for more is also lightly pushing us through the crowd to the exit.

As we all see what we never realized for ourselves until we watched this unfold for someone else.

and suddenly, you're someone else.

someone new.

you don't understand how you got here.

your old friends don't understand either.

but still,

they wish you the best.

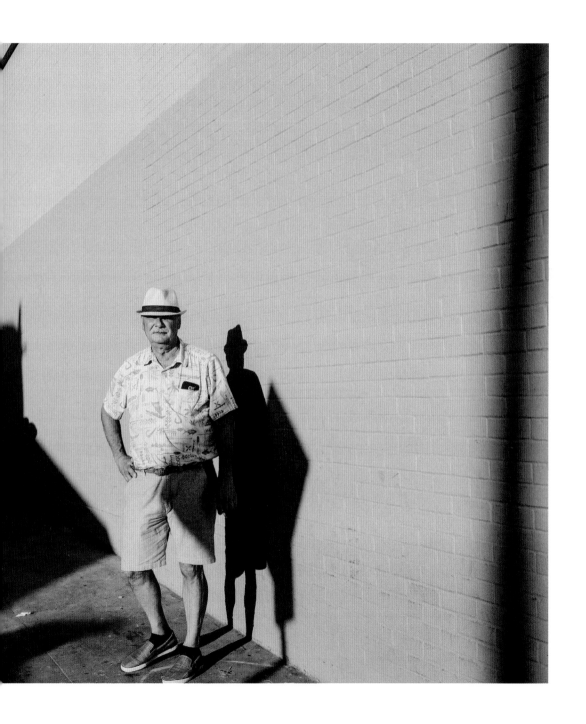

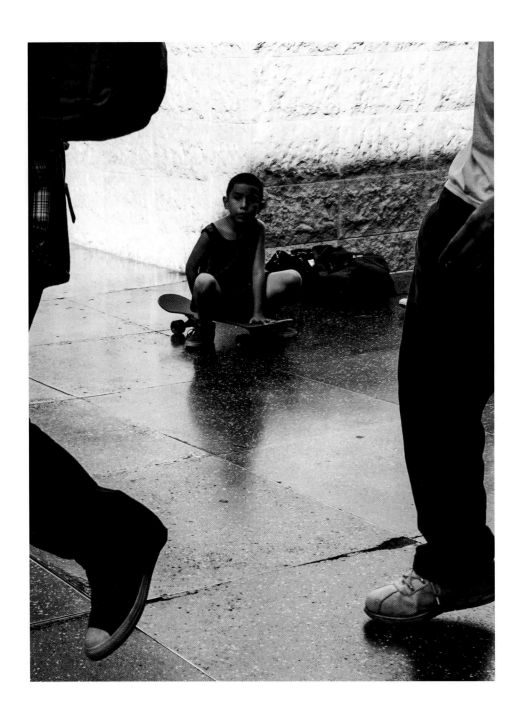

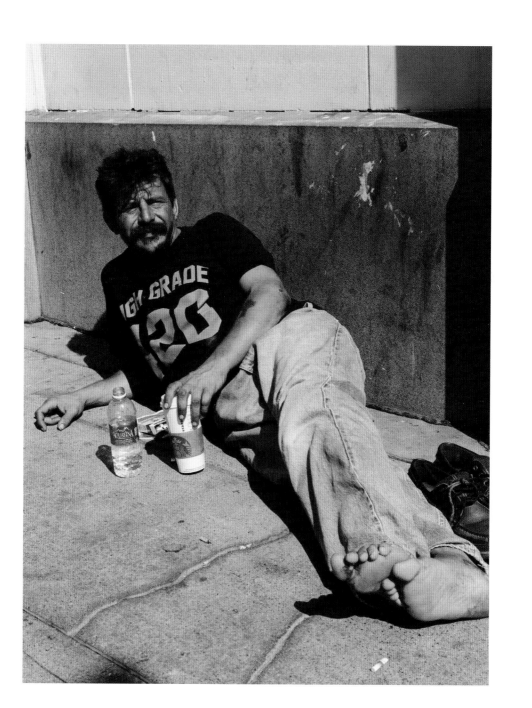

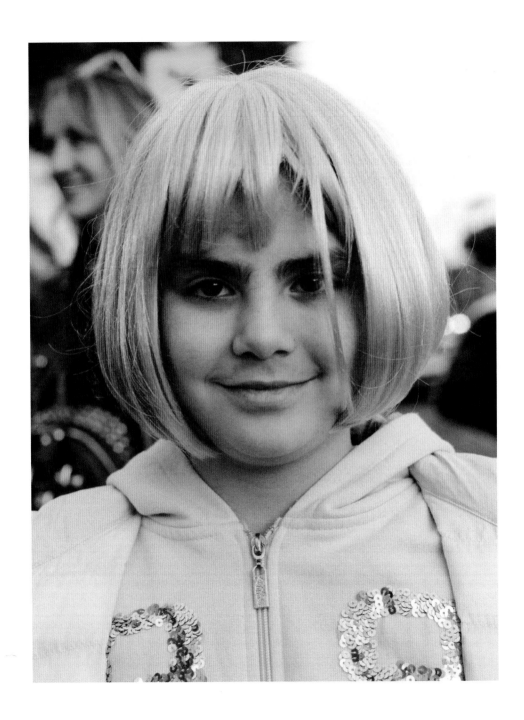

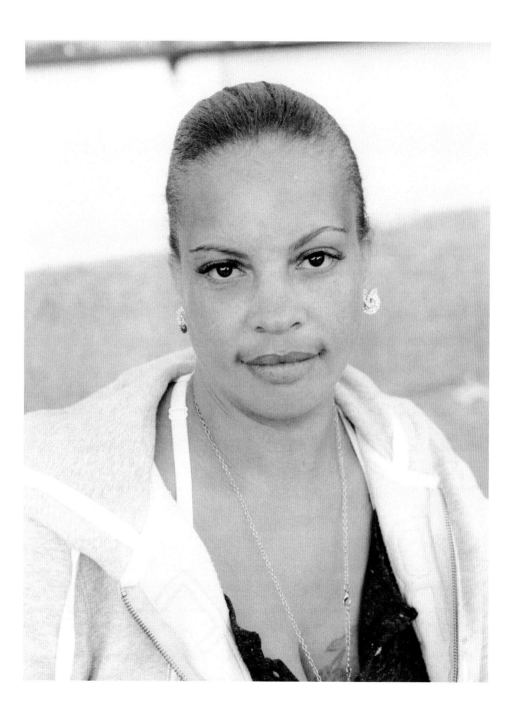

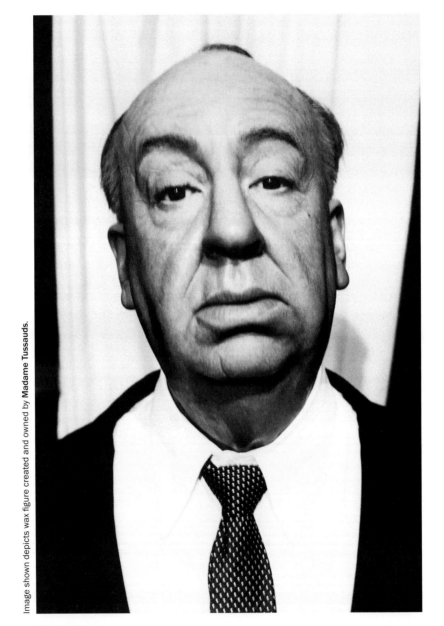

Hitchcock
Forever immortalized.

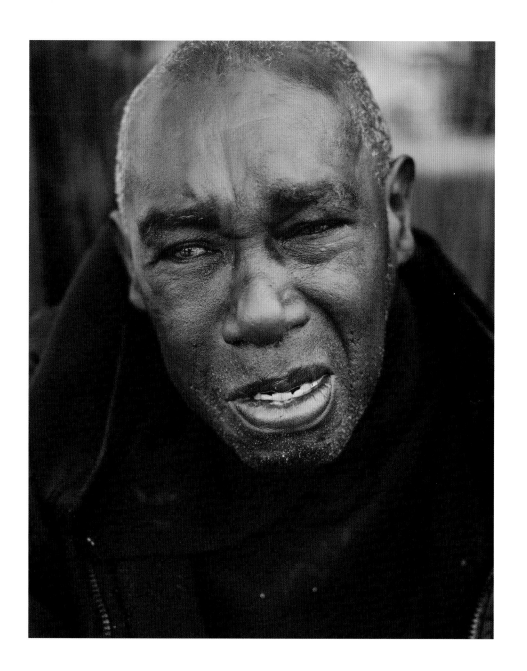

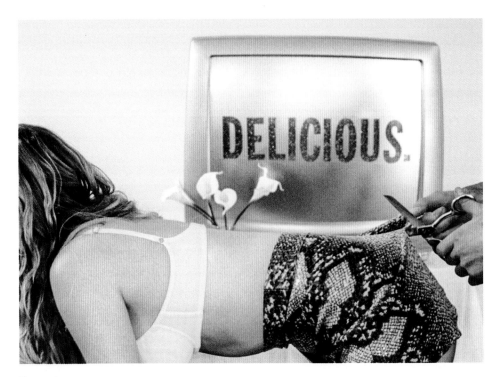

Pop art.

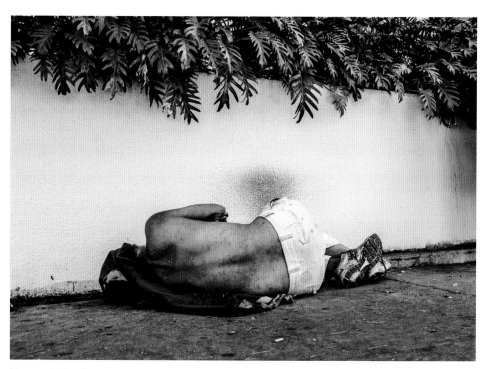

Beneath the fern.

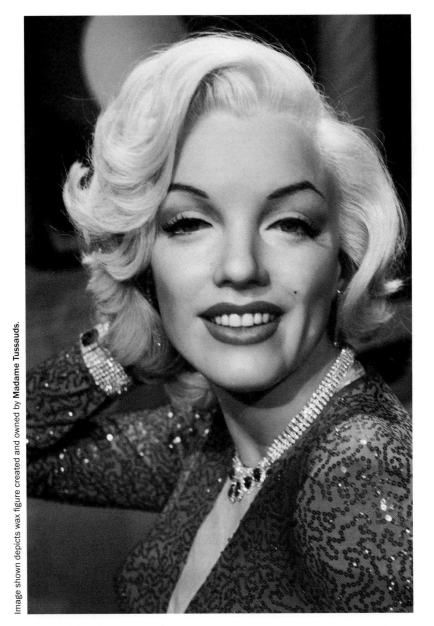

Marilyn Monroe
Forever immortalized.

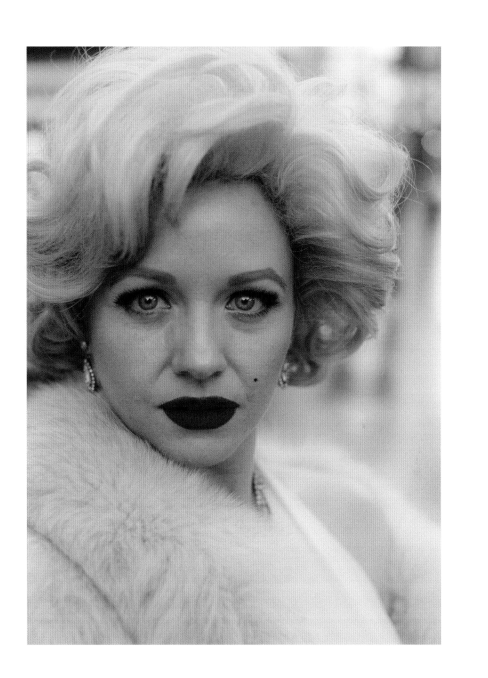

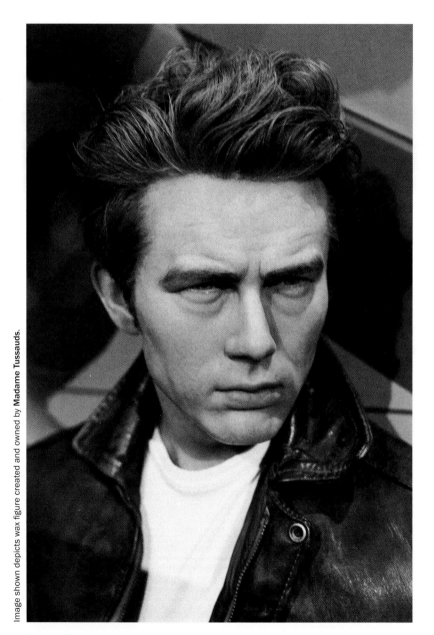

James Dean
Forever immortalized.

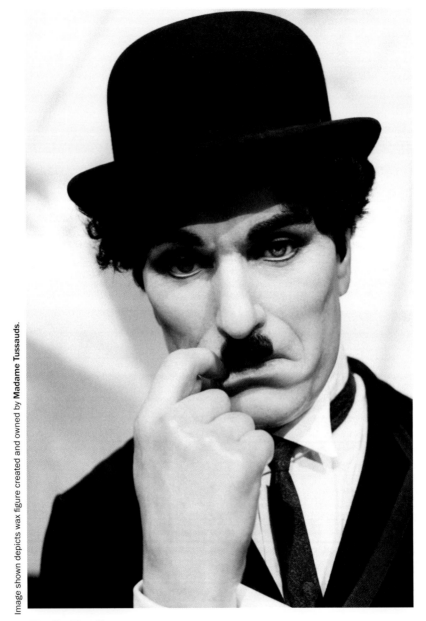

Charlie Chaplin
Forever immortalized.

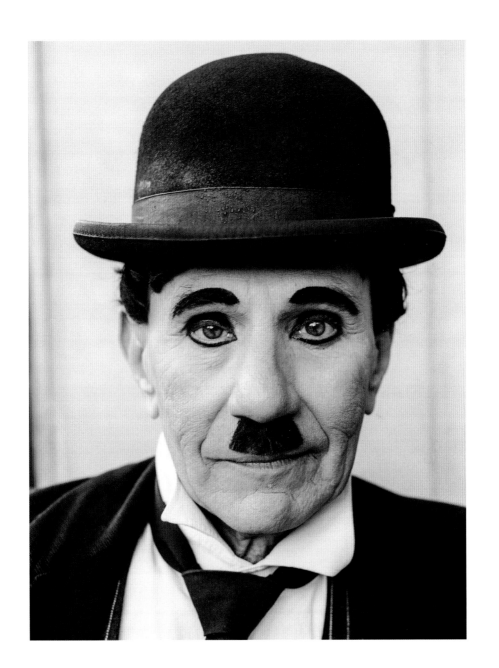

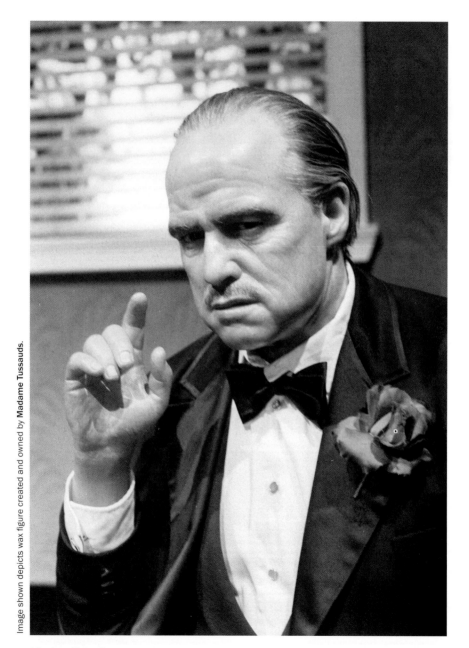

Marlon Brando
Forever immortalized.

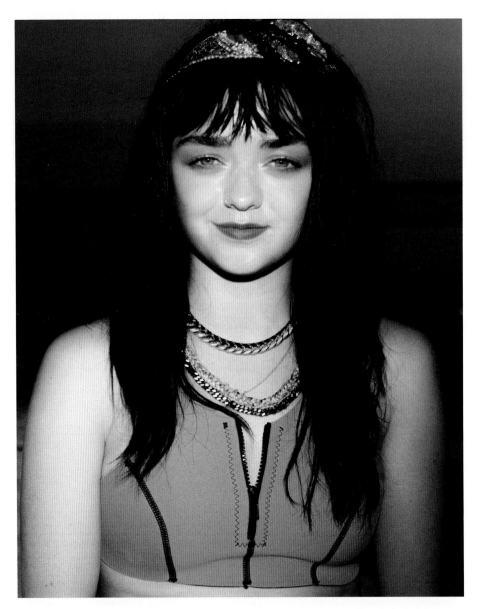

Maisie Williams has never shot a scene of *Game of Thrones* in Hollywood; however, she remains a Hollywood star.

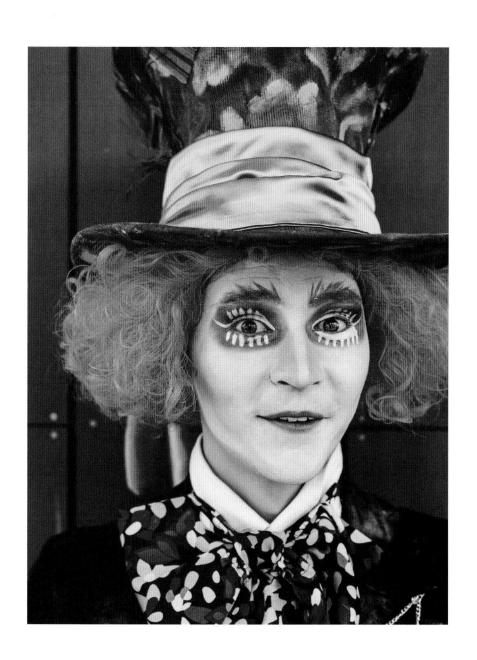

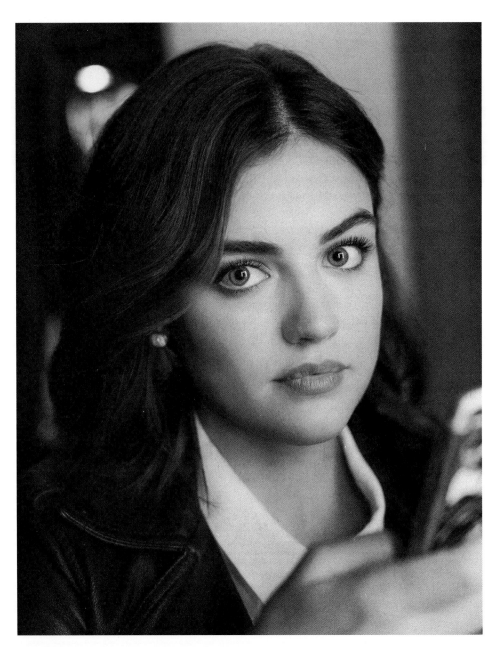

Lucy Hale.

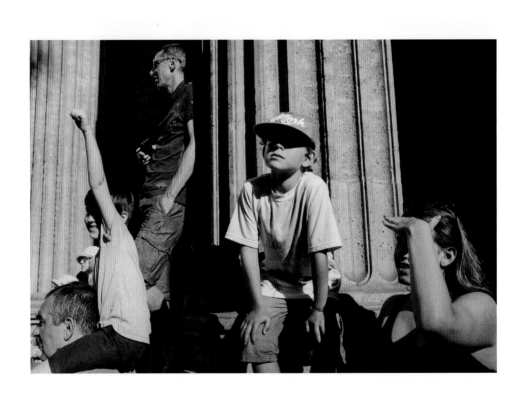

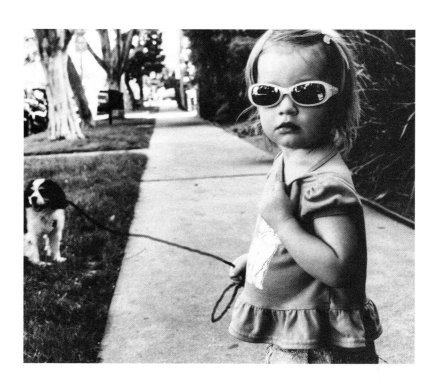

HOW I WENT FROM RICH AND FAMOUS TO A FORGOTTEN AND BROKE STREET PERFORMER

We all want to make money and use it to impress people. Tourists think I am impressed by their tips. "Wow!" they think I will exclaim. "This person gave me five dollars! Now I'm set!"

I came to Hollywood in 1984 and, after many auditions, got cast on a television show. Everything was wild. Good friends and great lovers. My parents never believed anyone could just come here and make a living. Home for me was a very conservative town, but of course, I wanted to show them that I could make a home and live a better life here than they had ever dreamed. I did it. A lot of people don't know that it takes a lot more luck, where opportunity meets preparation, to get a steady job here, and before all this "social" media . . . it was a very different world.

Living high and mighty with beautiful people telling me I was beautiful. I drank that Kool-Aid. I believed I was a beatific child who would always have work. All my friends assured me of my bright future.

I sent a letter back to my mother and father with a check for ten thousand dollars to prove my success. I had dreams of them receiving it and proudly calling their friends. I imagined their eyes reading the letter.

Pride comes before the fall, right?

Something happened.

Something changed, and suddenly I couldn't get a job to save my life. My money went so fast, and everything fell to pieces. Forget drugs—I couldn't even afford a meal. I am a street artist living off tips from tourists now. I used to live up in the Hills, drive a nice car, and sleep in a huge bed. Now my life is hard. About nine years ago, I saw my father walking around the Strip here, looking for me. I assumed my mother had died and when he fell on hard times, he came to find where his big star lived. I ran away and hid in a retail store. I couldn't let him see me like this.

I cry a lot less, but I feel like a failure every day, and it's because of the vicious circle. Believing in the next big break but having nothing to show for it yet. I'm constantly taking an emotional loan out.

I fear someone from my past will recognize me, so I am in disguise constantly.

I want them to think I made it out of here and found love.

I like to think they are cozy next to the fire at home, knowing that I was a success. I am too old now to get out of where I am. So I dream of a better world that can never exist, because to lose in America as anything is never what I wanted. But every day I come out here and work, and I feel like I can be everything I want behind this mask. People light up when they see me when I'm working. If only they knew who I am underneath.

Austin Stowell in character.

Josh Hutcherson in character.

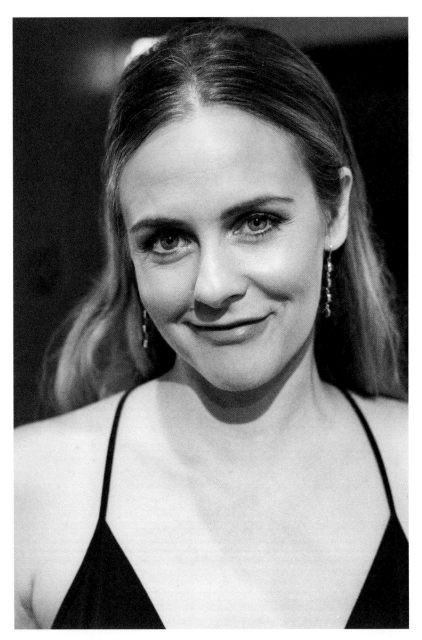

Alicia Silverstone.

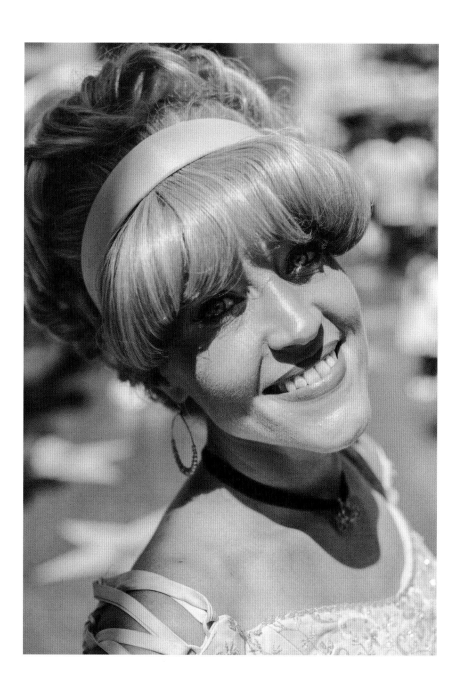

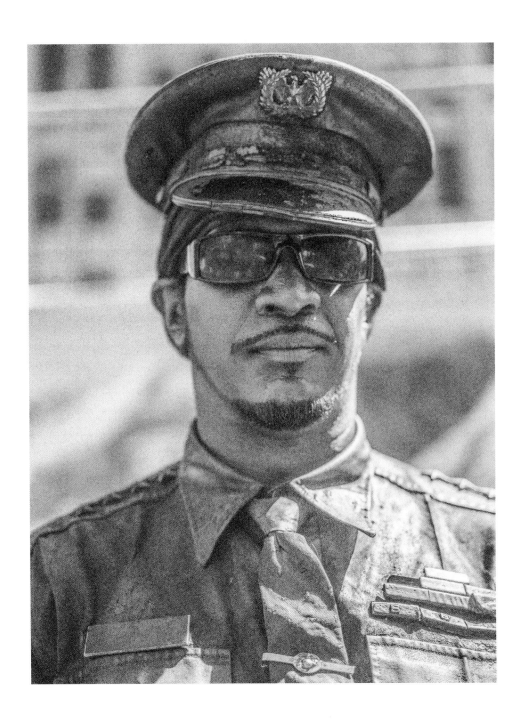

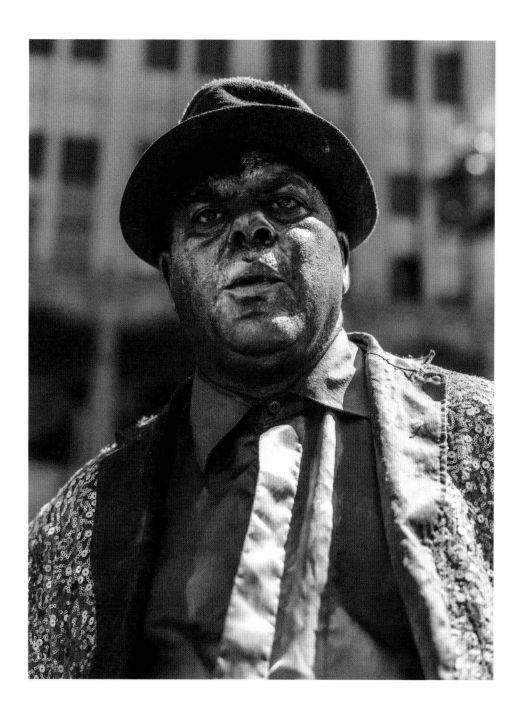

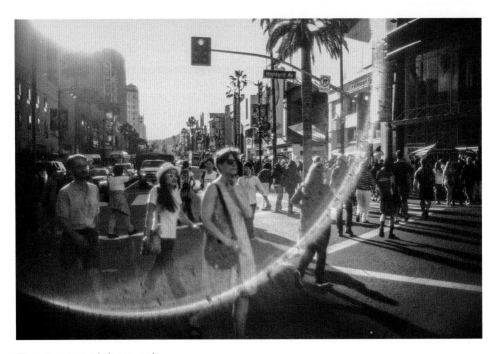

The streets and the people.

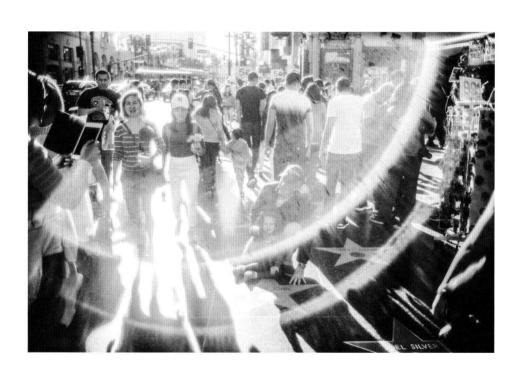

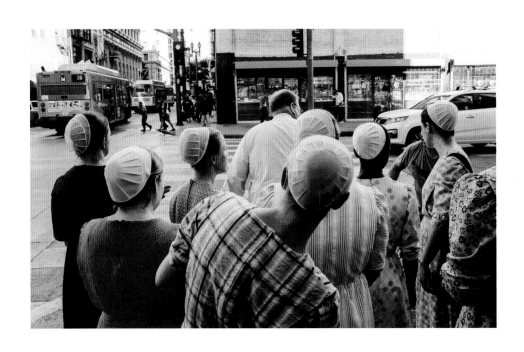

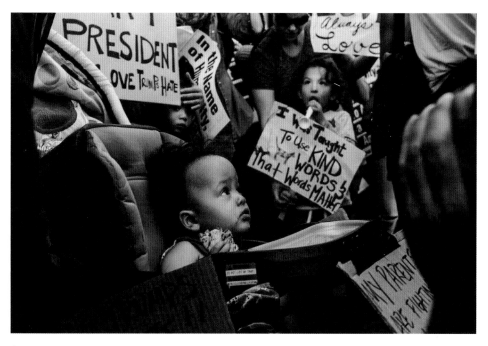

Sometimes, not being able to read
is a gift.

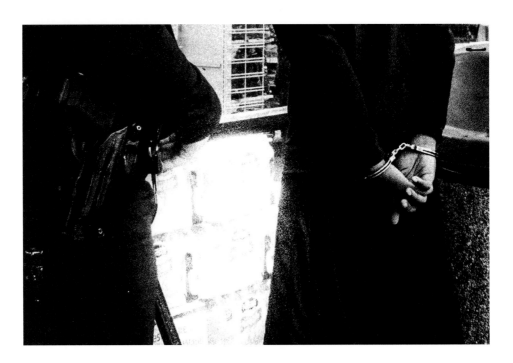

These streets also have a dark side.

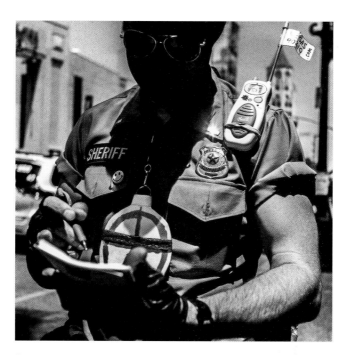

An actor.

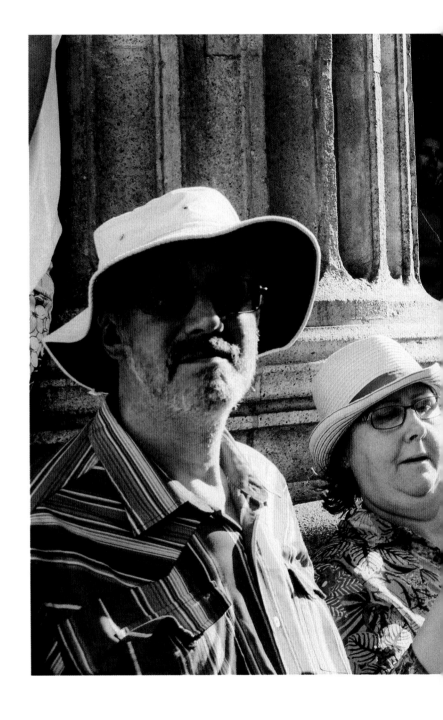

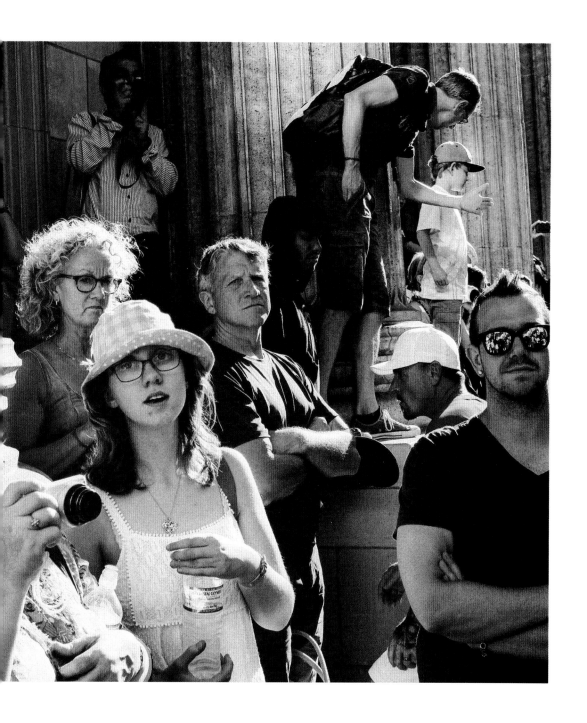

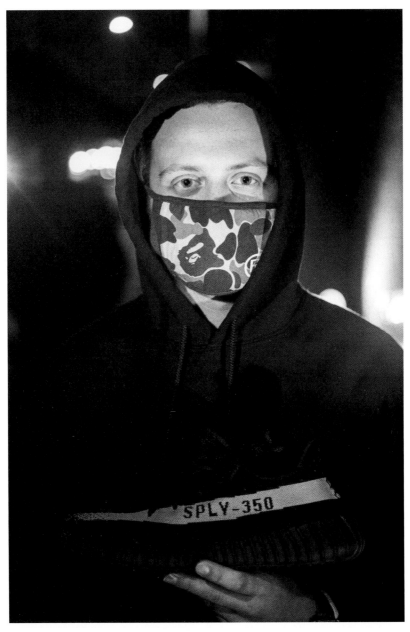

Yeezy Busta is known for spotting fake shoes. He must remain anonymous.

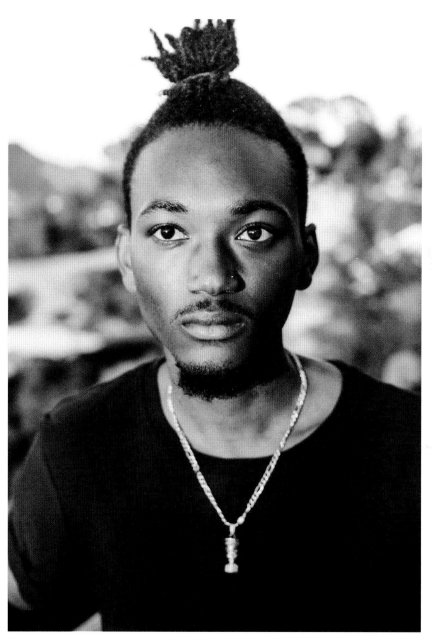

Everyone is a stranger until you appreciate them.

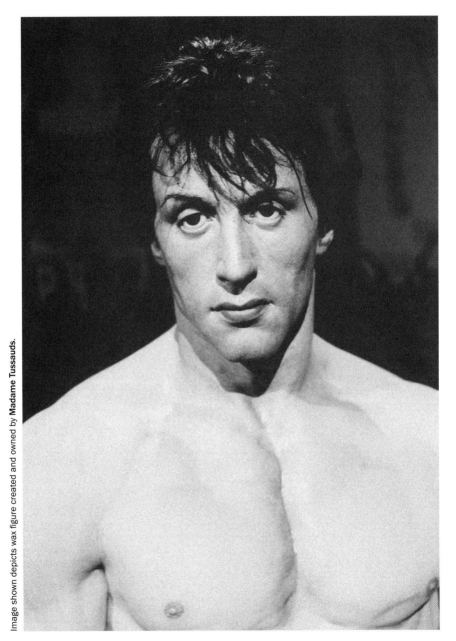

Stallone
Forever immortalized.

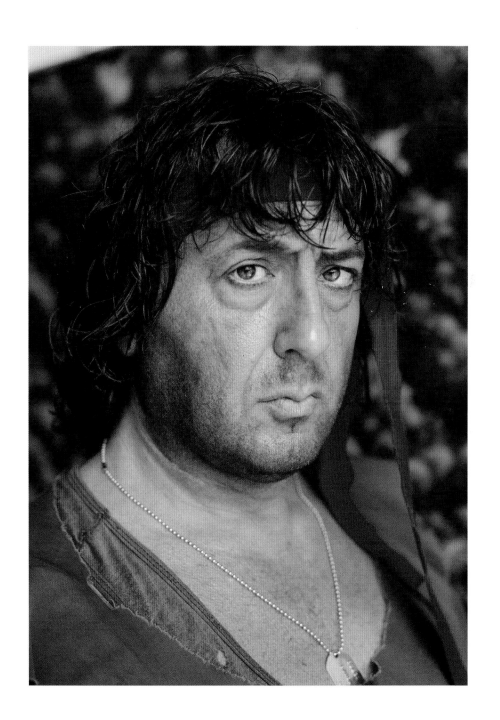

Simon Cowell
Forever immortalized.

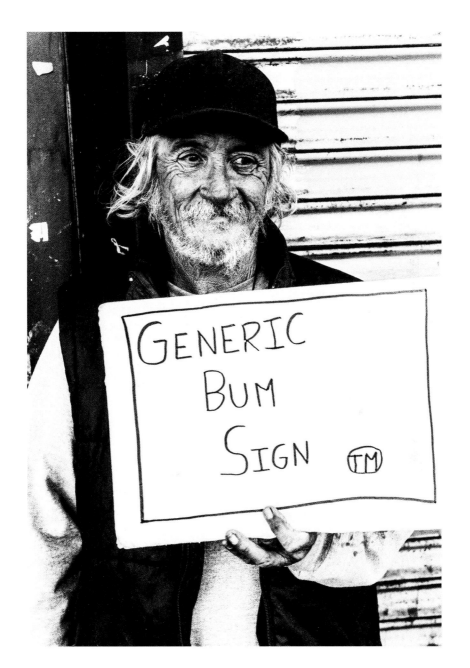

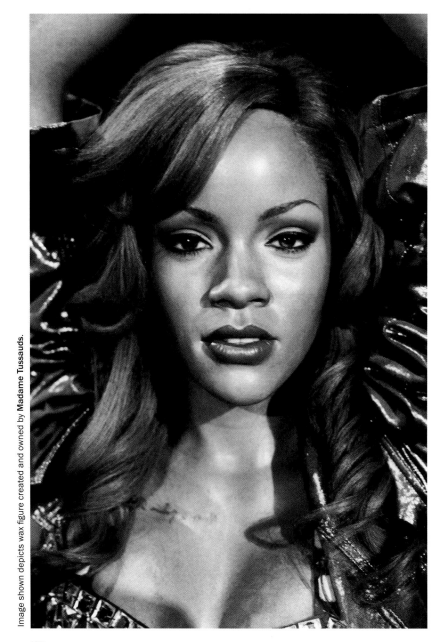

Rihanna
Forever immortalized.

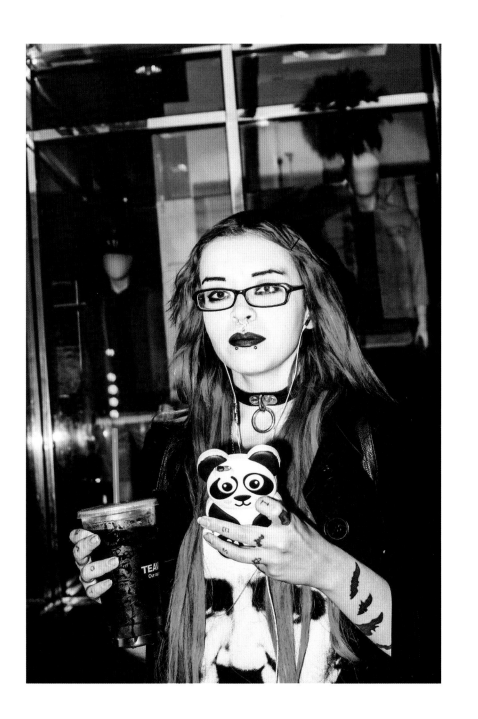

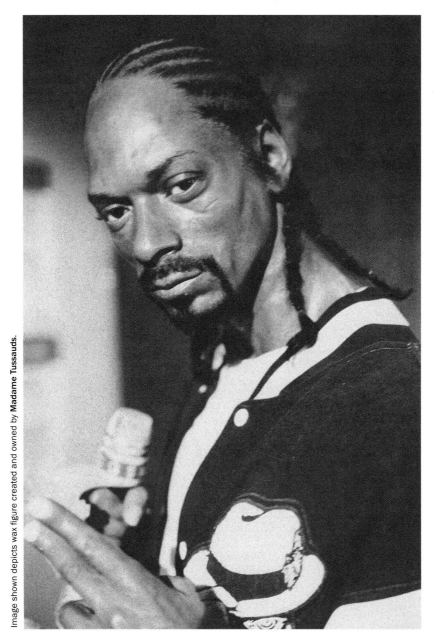

Snoop Dogg
Forever immortalized.

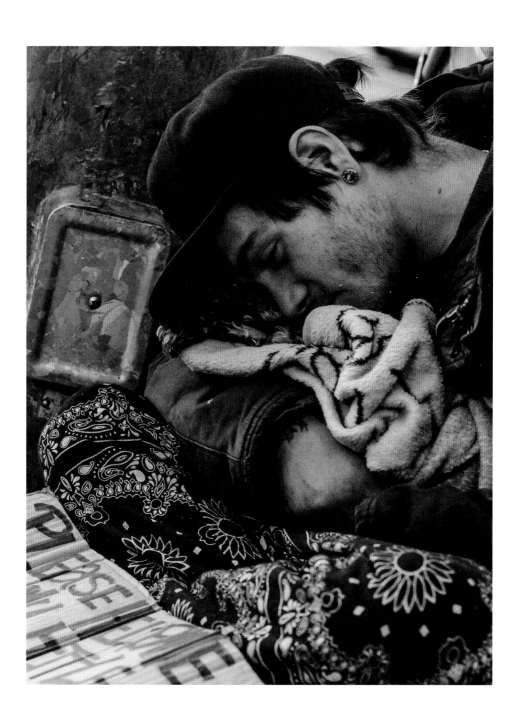

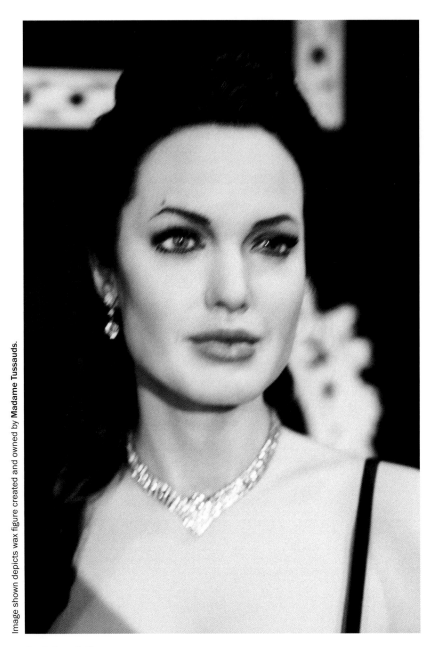

Angelina Jolie
Forever immortalized.

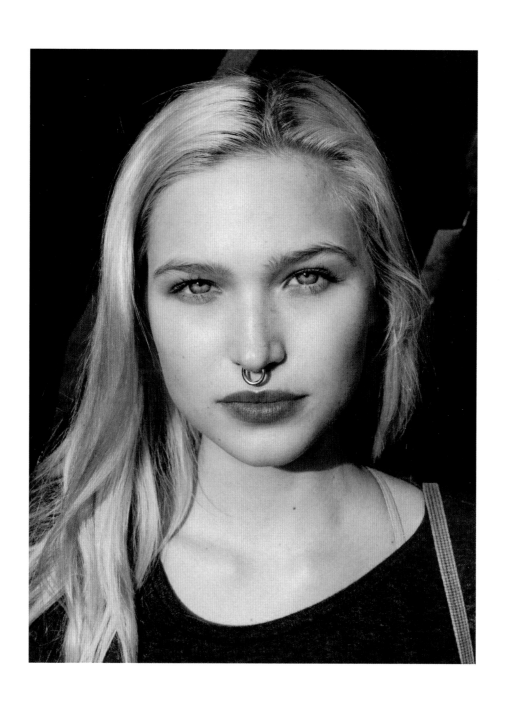

PATRON SAINT OF MY HOMETOWN

When I was twelve years old, the small town I grew up in deemed me the patron saint after my brother almost died in church from a seizure and I stopped him from swallowing his tongue. It was big news.

I was a little hero. My mother reminded me daily that I had to stay strong for the family and the community. I would walk around town, and everyone knew who I was. I was a real celebrity. People would shake my hand for good luck. I wore a white suit with white shoes every Sunday. No matter what, the clothing would get dirty almost immediately, but no one seemed to care except me. I cared how I looked. I felt like everything I did was so closely watched. Everything I said could be taken out of context, and my father would unknowingly tease me by telling me, "You have to be careful what you say; they may write it down in the papers and it will live forever."

A couple years went by, and I was waiting for my auntie to pick me up for a driving trip to see my grandpop about two hours away. My neighbor, who was very jealous of my "fame," had come walking by with a half-drunk six-pack. I was still a child and I didn't know what was what.

This boy chucked a beer at me and told me to take a sip. I still remember that beer flying through the air, and I didn't catch it—that should have been a sign right there—but I blew off the dirt and cracked it open. It was bitter and actually not as appealing as it would be now, but I drank it.

When my auntie came to pick me up, I thought for sure she would smell my breath and I would get caught. But she didn't even notice or say a word to me about anything other than that my granddaddy was very angry with her about some man named Louis, who I found out later was a man she was seeing while being married to my uncle. Bad times. Lots of tears for me to see. I wasn't a saint who could fix it.

I started sneaking out at night to drink and forget my shortcomings. Everyone still recognized me, though, and I had to hide in the dark places. When my mother passed away, my father beat me when I showed up to her funeral very intoxicated. He told me I was the glue that held this community together, and I'd let him down. So I turned in my wings for a shot at heaven.

I left the small town and hitchhiked to Hollywood to live with a group of people up on Mulholland, overlooking the city. We didn't have no fancy house; we slept in a car. That was okay back then, no tickets and no police telling you to leave. Just . . . peace.

I wandered around Hollywood, and to this day no one believes that I was a real patron saint. I'm another nobody here. A shadow behind the people walking around. Everyone just thinks I'm a drunk, but at least you will know—you met a real patron saint, right here in Hollywood.

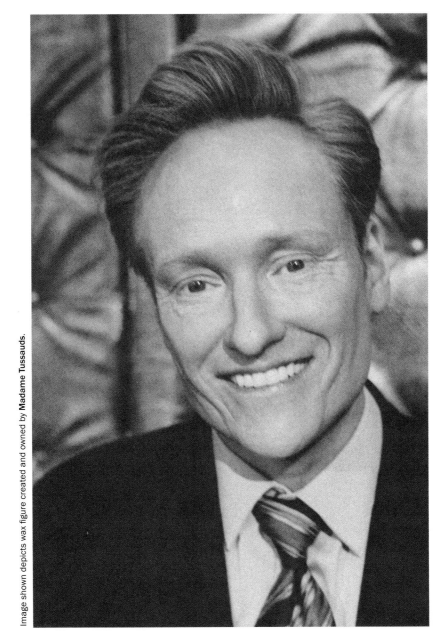

Conan
Forever immortalized.

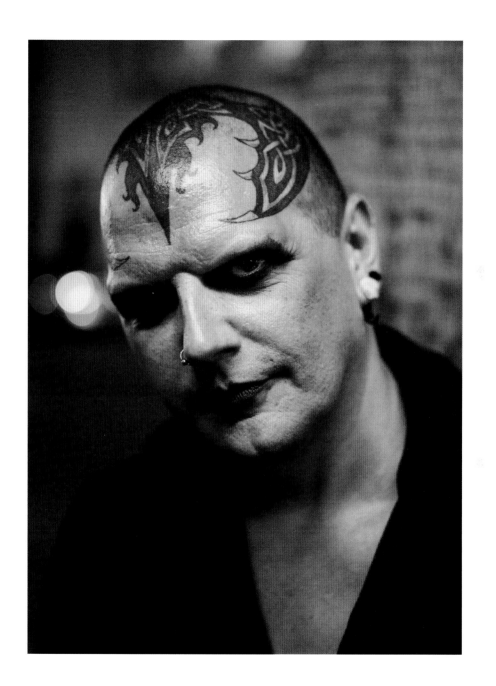

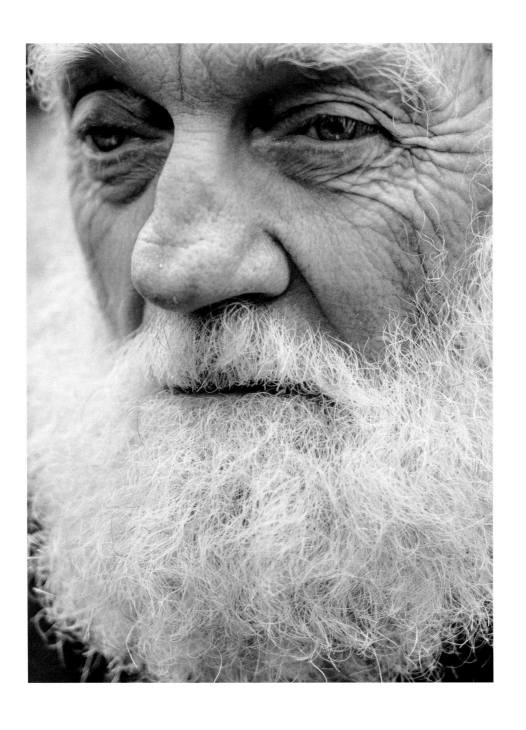

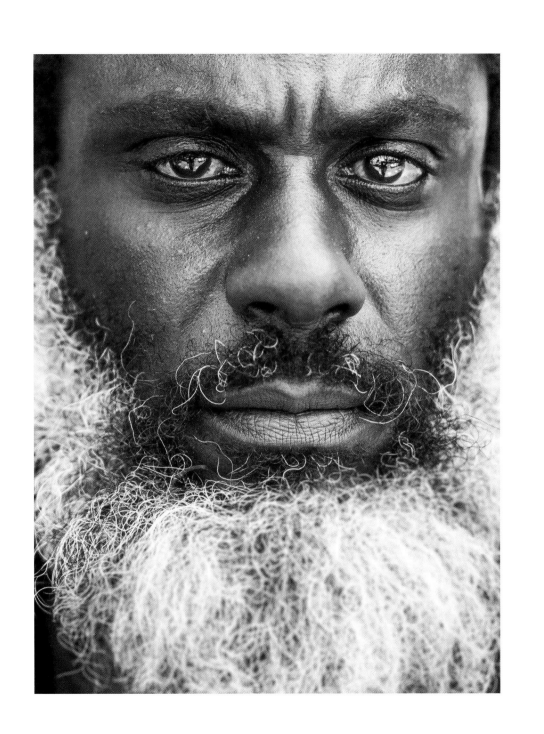

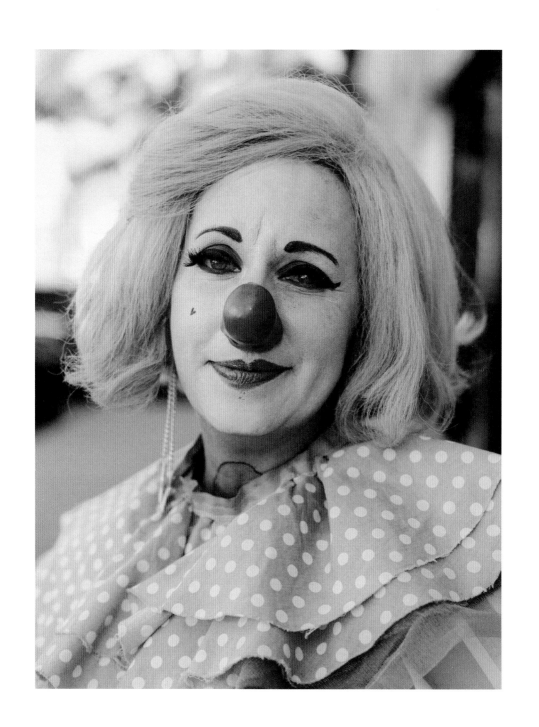

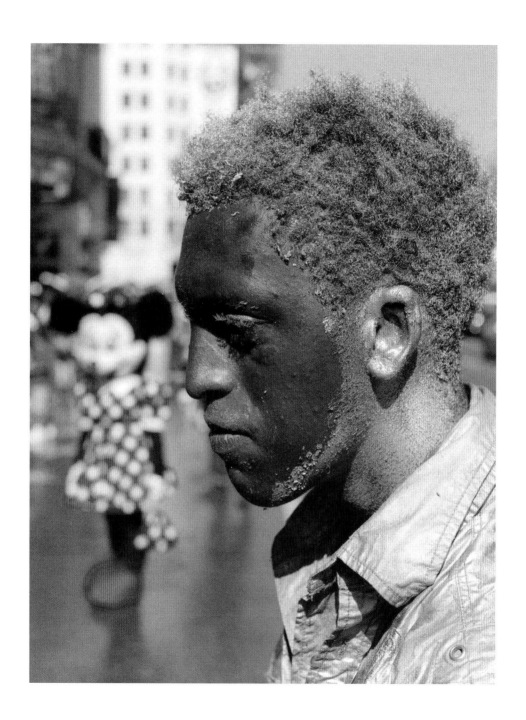

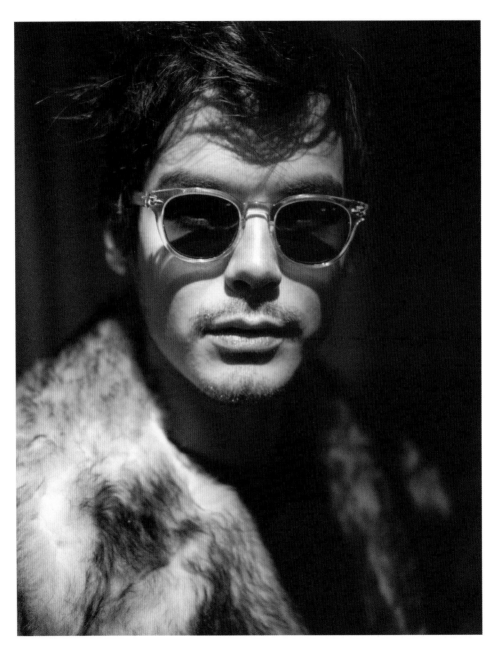

Tyler Blackburn.

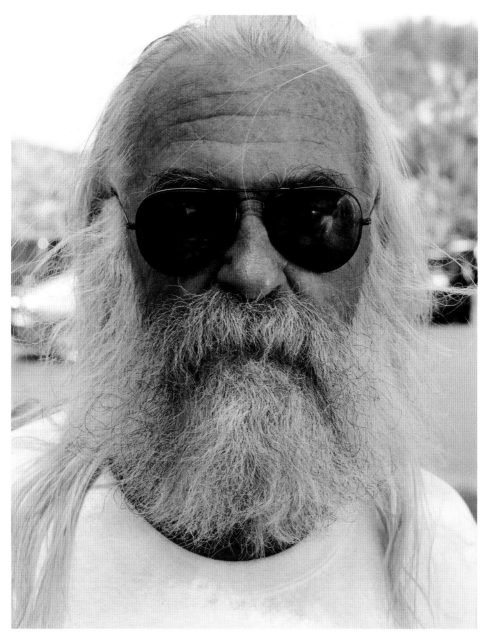

Grifith Park observer.

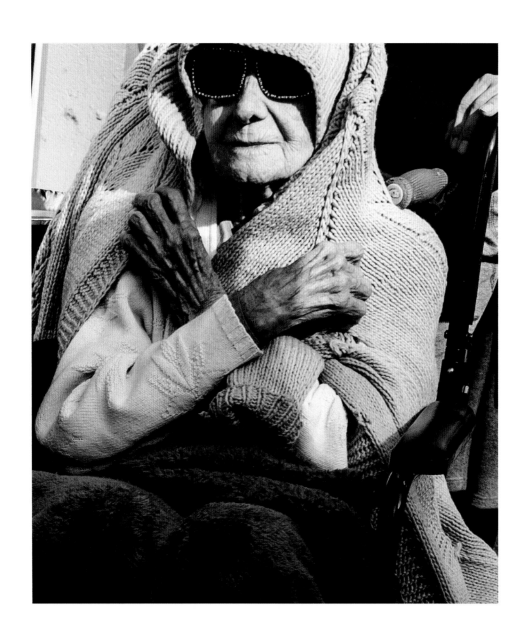

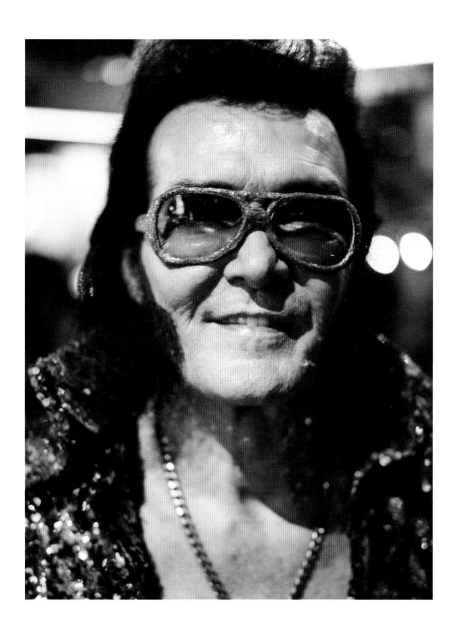

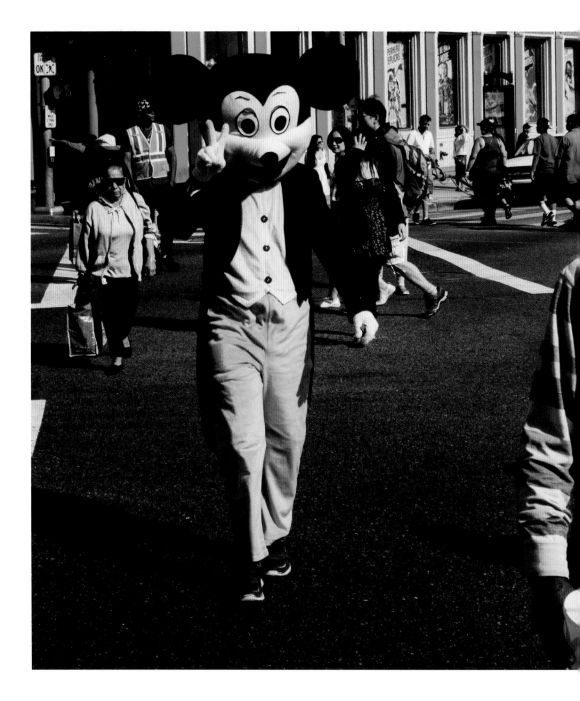

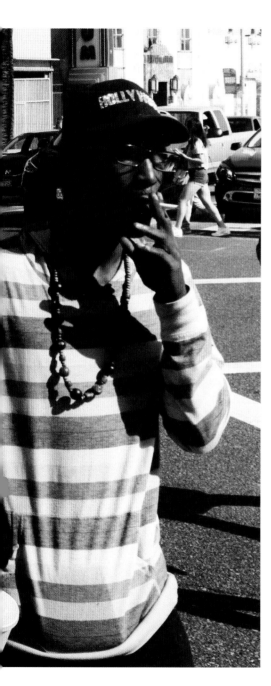

It's not a normal place to walk around.
Everyone around here is running from birthplaces.

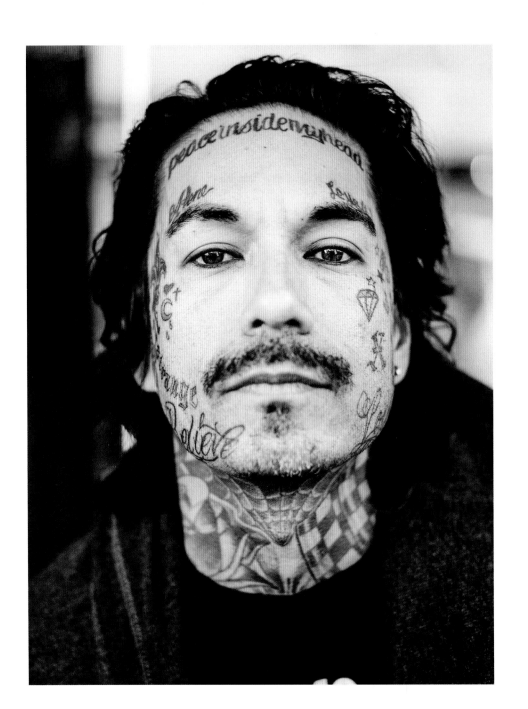

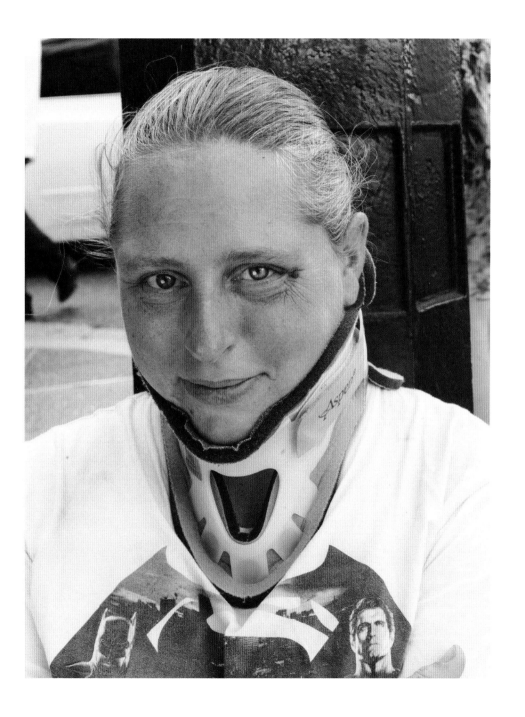

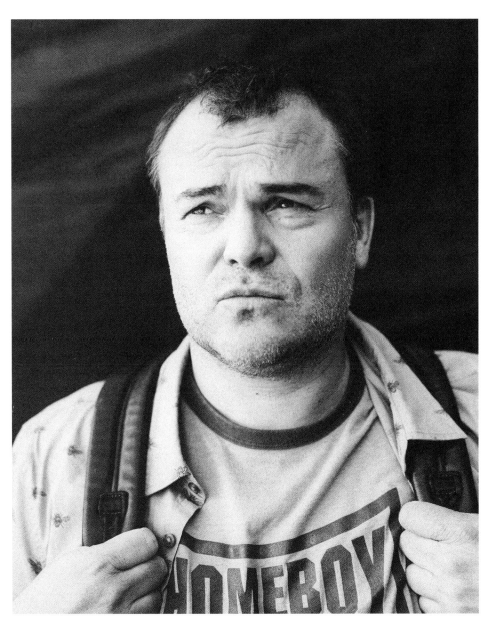

Jack Black
Actor/Musician.

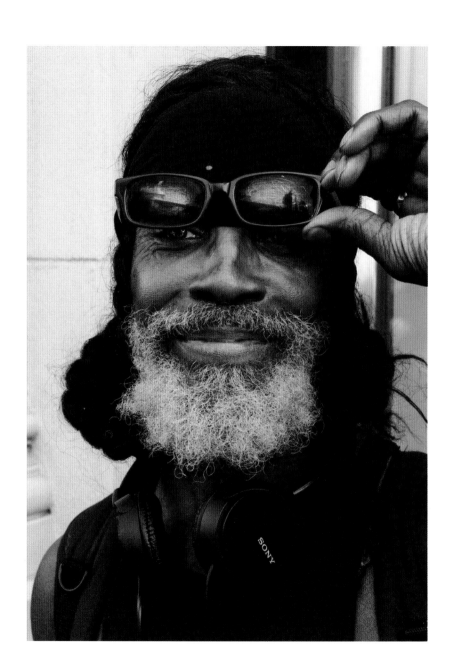

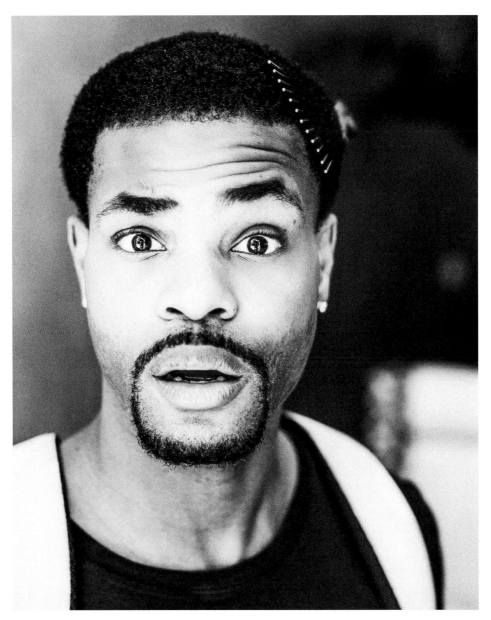

King Bach started making videos for social media. Now his production company works with top actors weekly. A great example of the Hollywood dream.

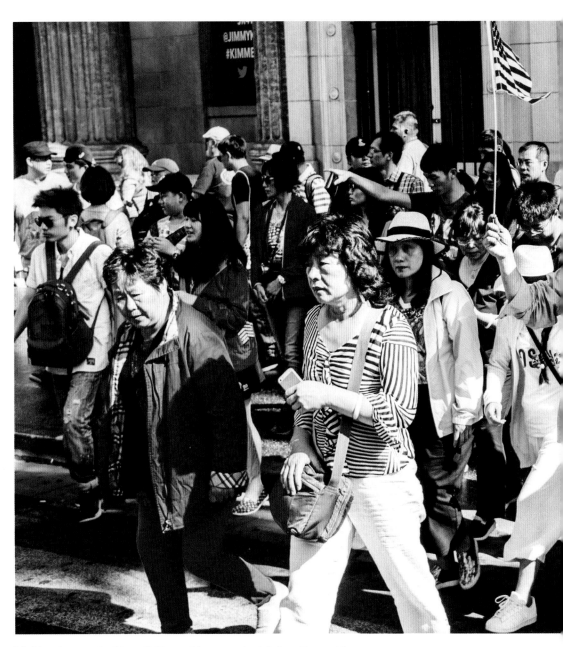

Visiting from out of town? No problem . . . Just follow the guide.

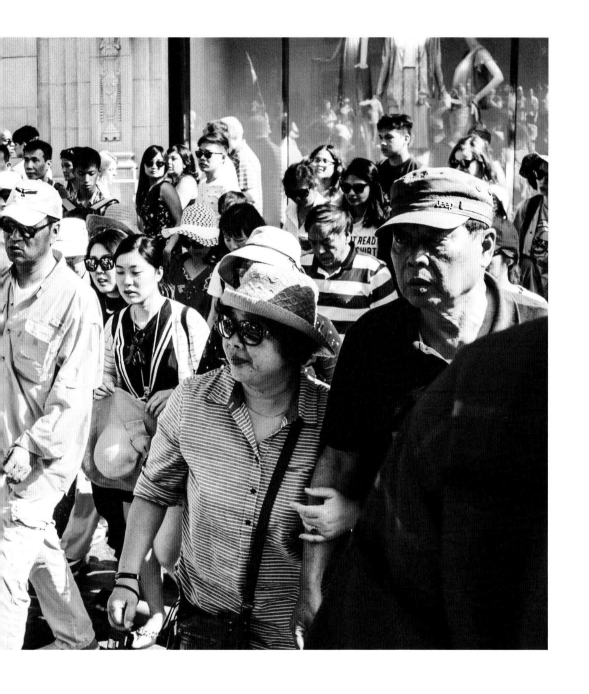

MY DAD ALWAYS BELIEVED IN ME.

He was a harsh man on himself, but everyone was. He told me he acted in a few things here and there, never really let me into his world. He thought of it as protection; I saw it as distance.

I was young, so that made our relationship harder. I was a difficult kid, constantly in trouble.

Break a window? I'll do it! Steal pens from Morning Glory? Sure. Steal a friend's car and crash it? I'm the person with no fear of the outcome. I was immune, invincible. I rode home in the back of cop cars a lot. They would drop me off at the house and ask for a picture with Dad, the whole time telling me how lucky I was to be his child. Eventually my mom gave up on all of us and left full-time, but we had to "pretend" like we were a family. We have been pretending since before I was born.

Sometimes dad would drink in the guesthouse bathroom.

I caught him talking to himself in the mirror, and it gave me nightmares. He was looking at himself like he was someone else. My mother would whisper-yell at him in the home theater because it had soundproofing. I had a crawl space that I would sit in, my ear to the wall. I heard everything. It hurt to know the truth.

Mom was always paranoid that people were listening, because they were.

Seeing yourself on the news is annoying at school the next day. If Dad did anything, everyone had something to say.

Overwhelming. Everything got out of control. It's scary as a kid to be out of control, but that's expected from time to time. I had training wheels fastened to my heels.

My parents didn't have control. They were so caught up in the drama of their existence, they forgot about my childhood.

My mother collapsed in the kitchen and started crying. She didn't recognize me anymore. She said she "missed it."

I grew up too fast.

I felt the guilt.

My dad continued to make movies that everyone knew. He got older.

I moved out but stayed in Hollywood because it will always feel like home.

The Liquor Locker, the Chateau, the Sunset Tower, repeat.

I don't talk to my parents now, but they pay all the bills. I have my own apartment.

My dad doesn't really have time to see me. He works on location, mostly. His agent is a better "dad" to me. He gets me the best gifts and always answers his phone. I've called him crying about Dad many times. He always says, "I know, I know. . . ."

People see my life the way they want to see it, without living it. Without even knowing a real day in my shoes. I would switch places with you if I could.

Some of my friends' dads are famous too. They call people who aren't famous "plebs." My friends and I don't pay for anything.

I've been to Hollywood Boulevard a few times to visit Dad's star. It's not weird to me; it seems normal. What weirds me out is that no one can relate to me.

I'm alone and unknown. But so are you. . . . We all are eventually.

Christian DelGrosso was making comedic six-second videos from Canada. Now he lives in Hollywood and has a bigger following than most entertainers.

Michael Gambon could probably use this gentleman as a Dumbledore double.

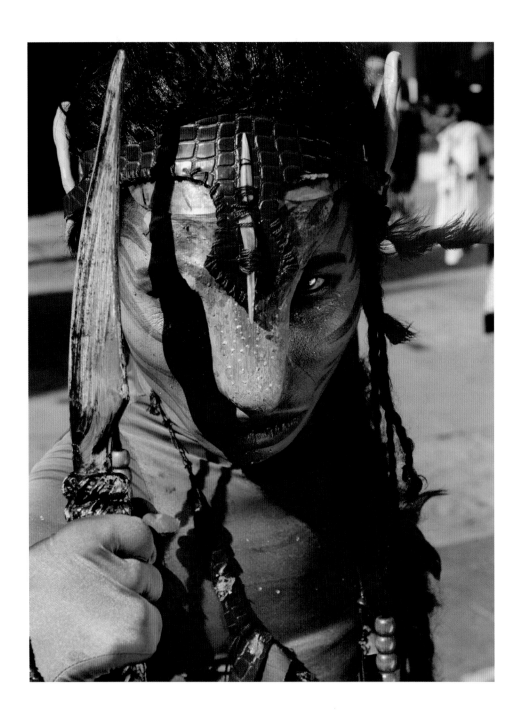

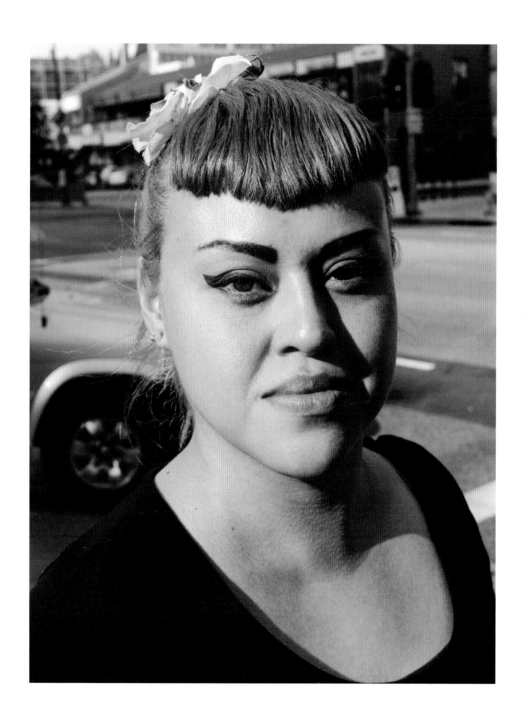

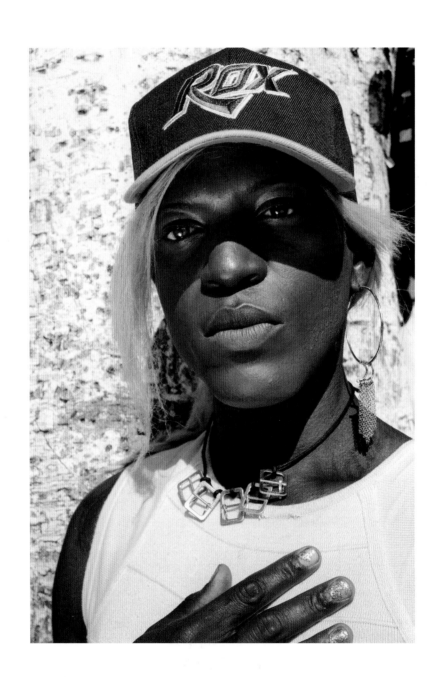

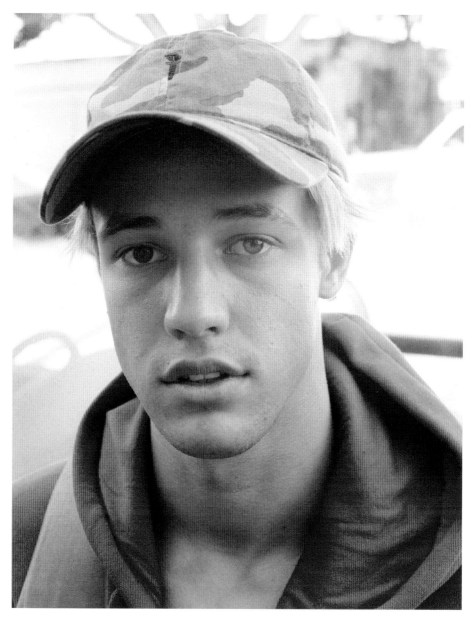

Cameron Dallas can go under the radar when he goes out in public, even though almost twenty million people follow his every move on social media.

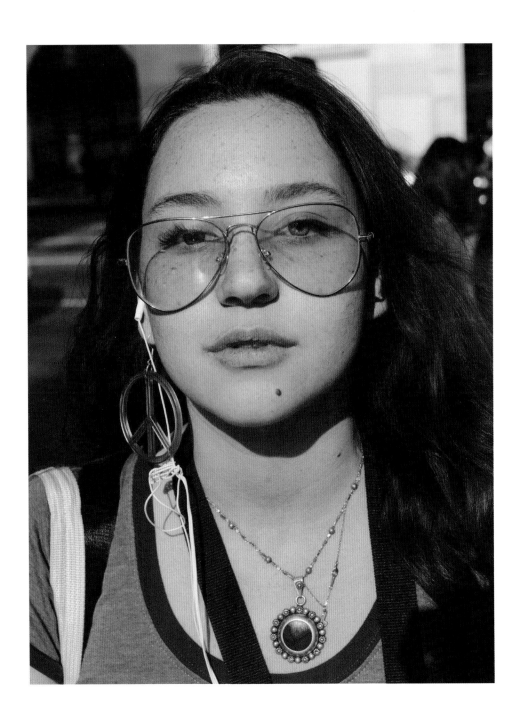

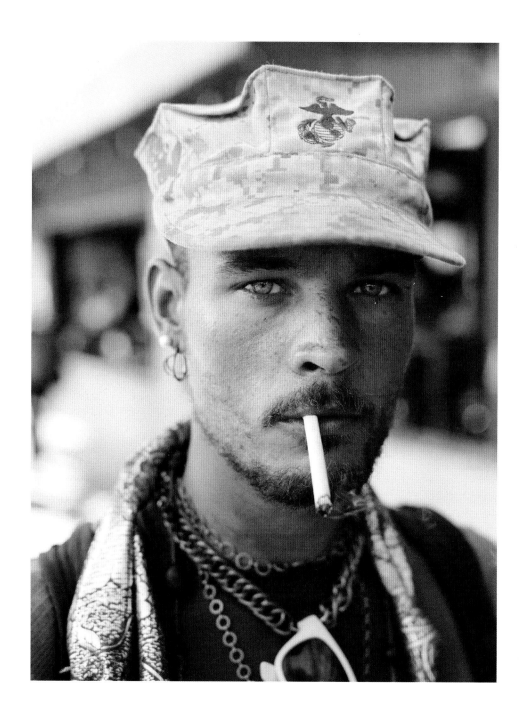

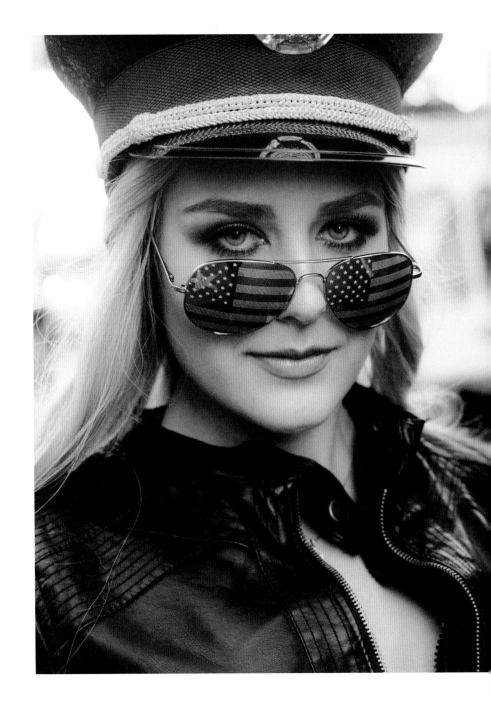

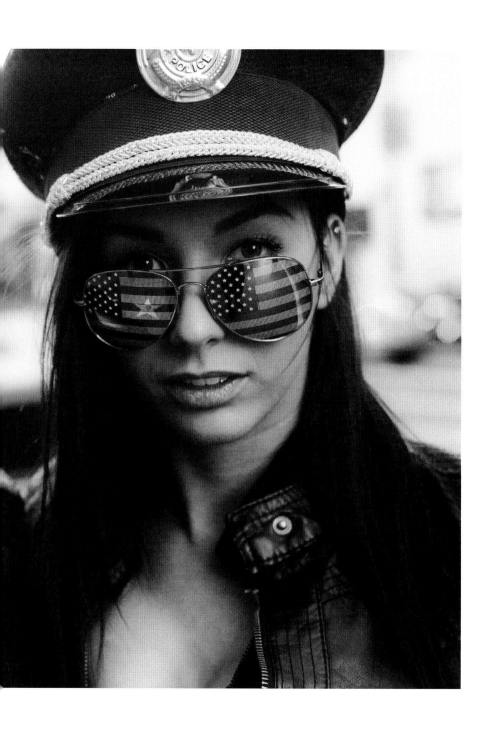

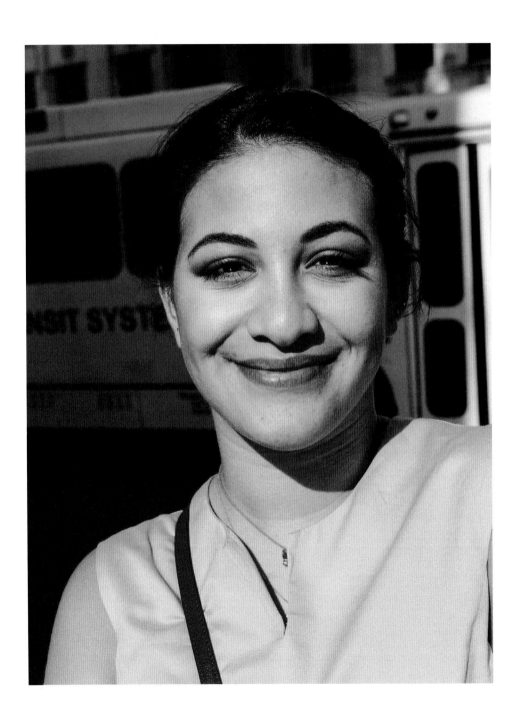

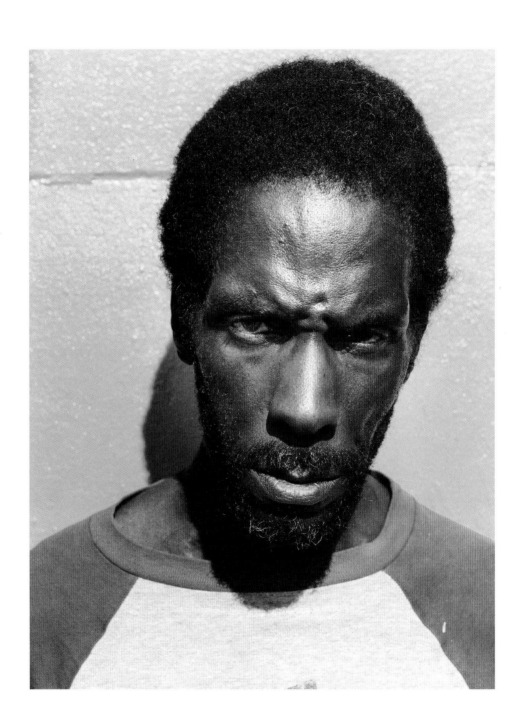

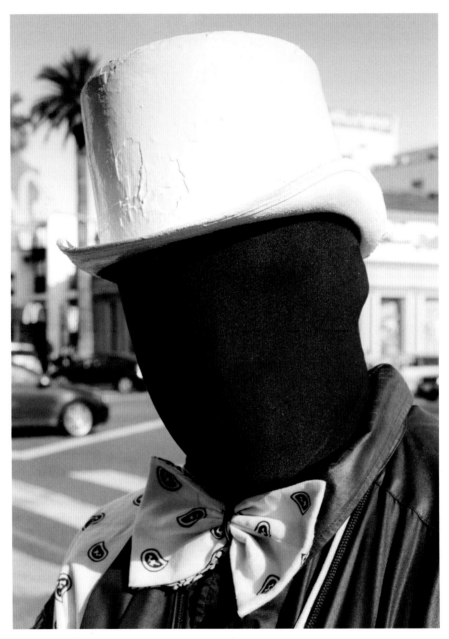

Sometimes even the faceless and nameless stand out in the crowd.

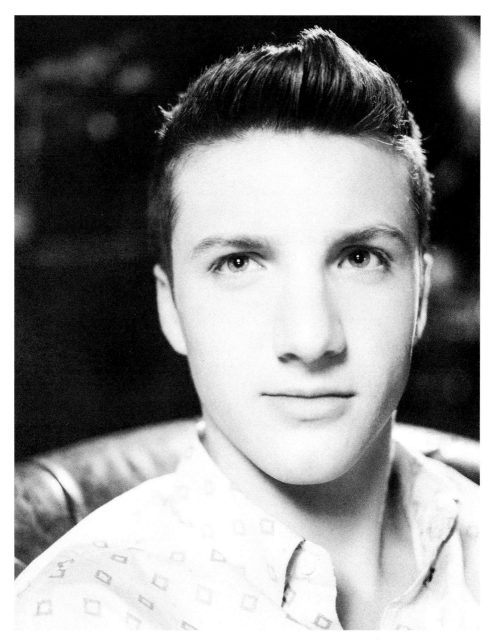

Jake Short as the matinée idol.

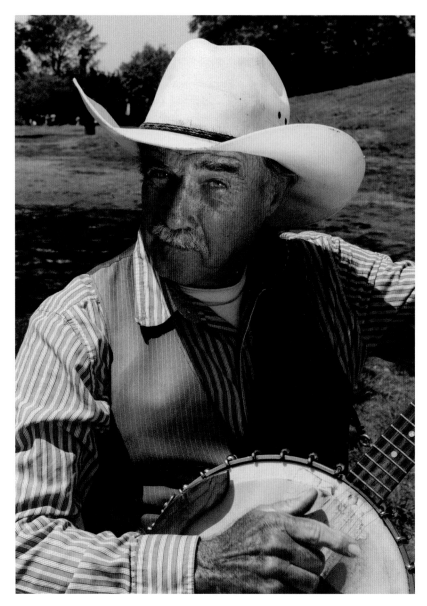

For decades, Charlie Cox has been entertaining folks visiting from out of town with his charming Hollywood fables. If you are lucky enough to stumble upon him, ask for a tune and the story behind a famous Bob Dylan anthem.

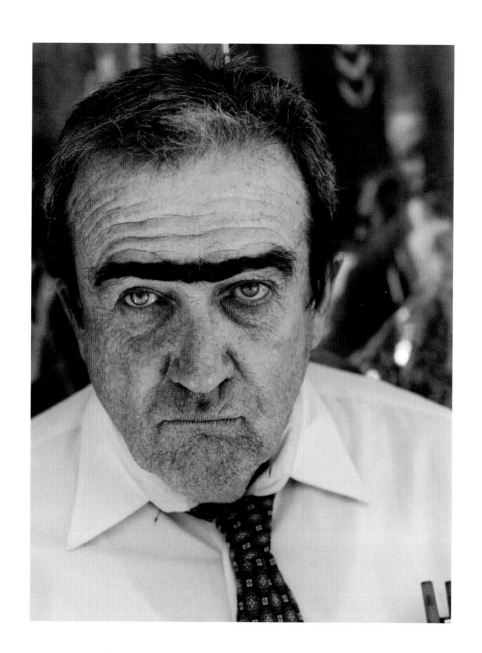

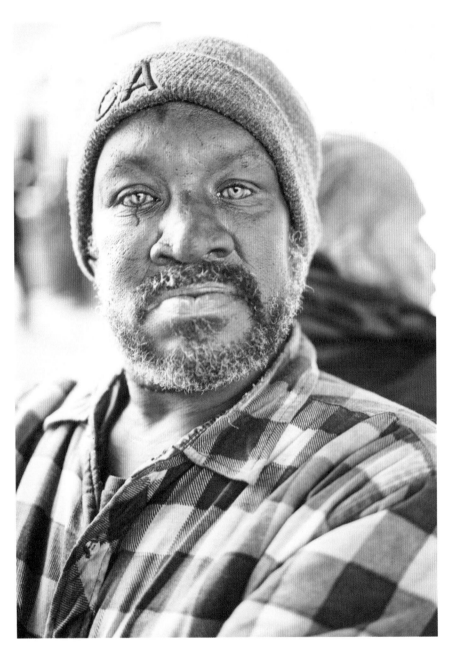

The eyes. The secret.

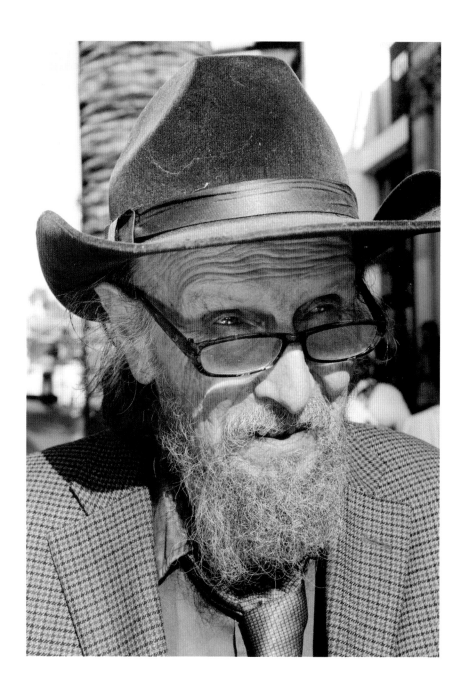

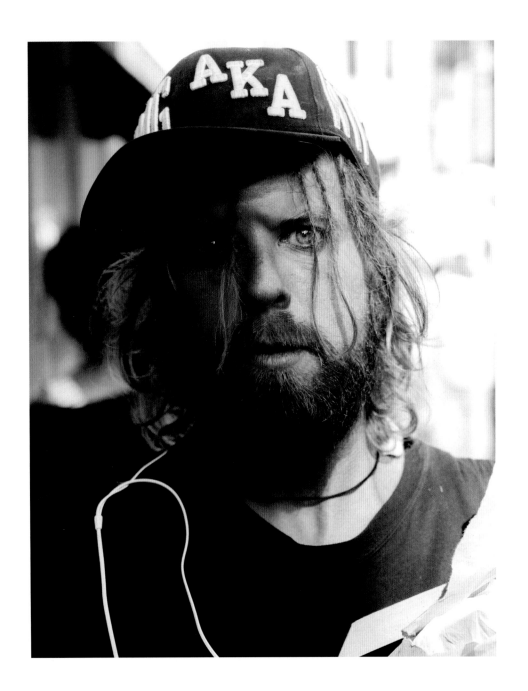

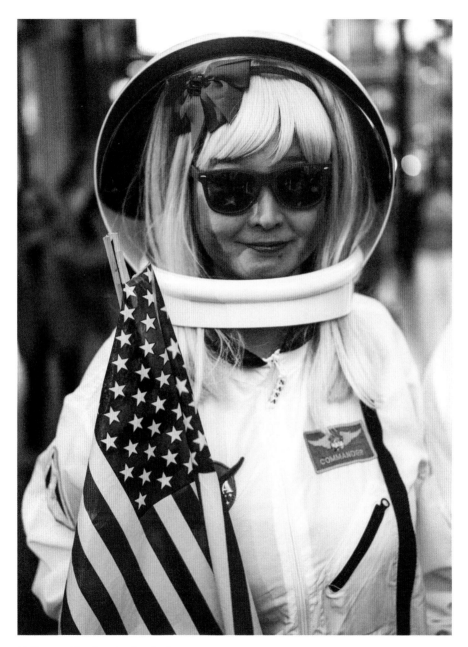

Hollywood is also the land of astronauts.

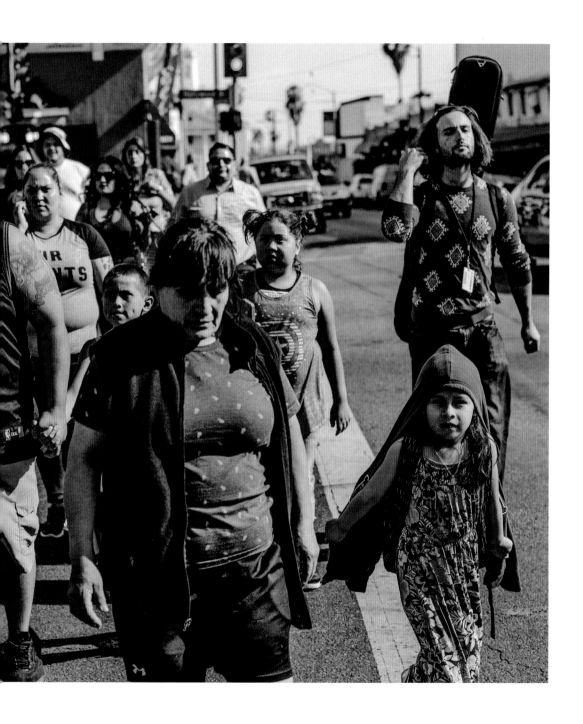

MY HEAD SHOT SAVED ME FROM GETTING TOWED

My friends and I were all piled into my tiny car, looking for parking on a Friday night. Most people wouldn't even try to bother with parking, but I had a trick up my sleeve. I was dating a well-known actor who lived in the area for a couple weeks before I broke it off. He lived right where we were looking for parking. We ended on good terms, so I decided to park in his driveway. Just so he knew it was me, I put my head shot on my dashboard. I was still nervous that my car would be towed.

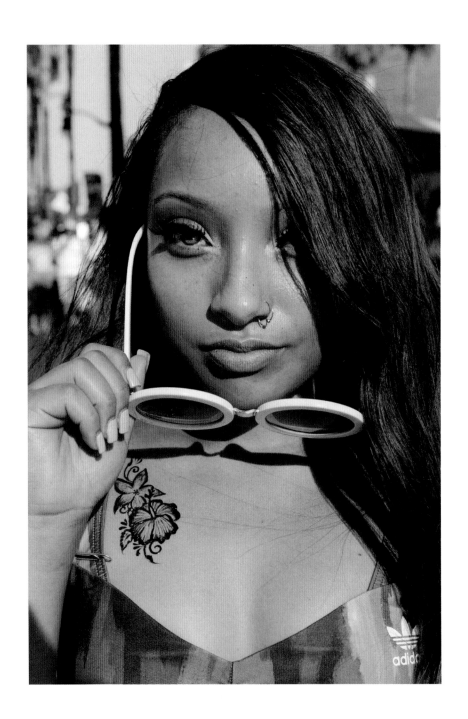

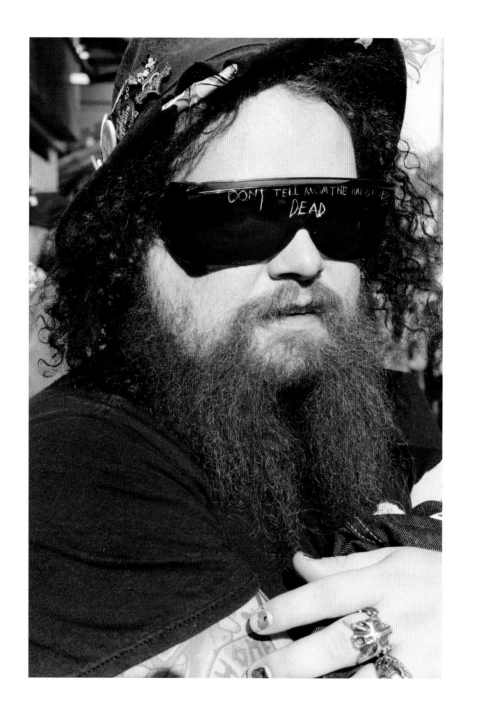

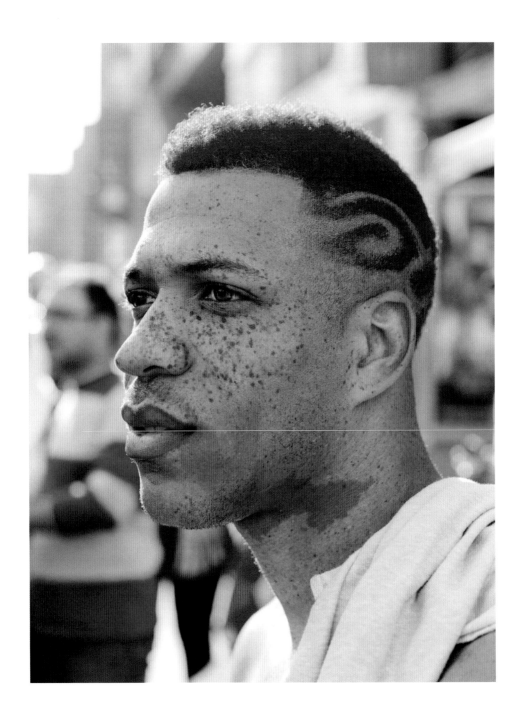

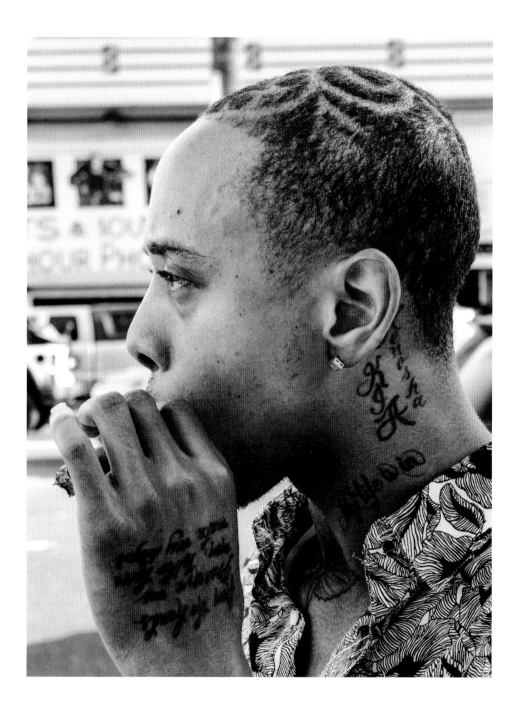

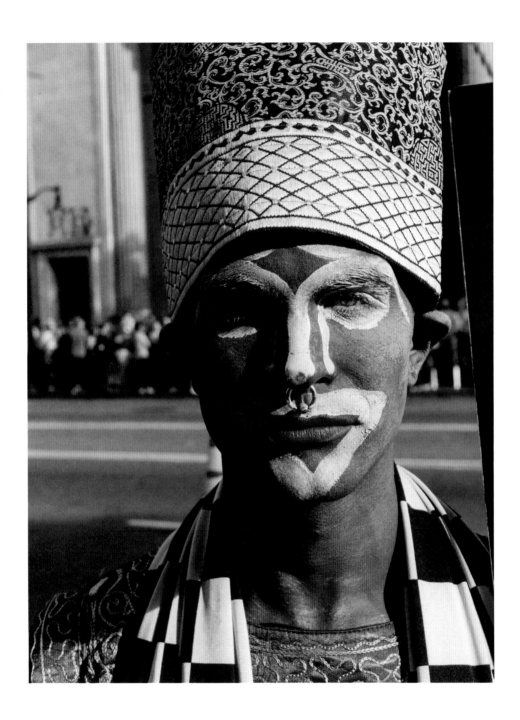

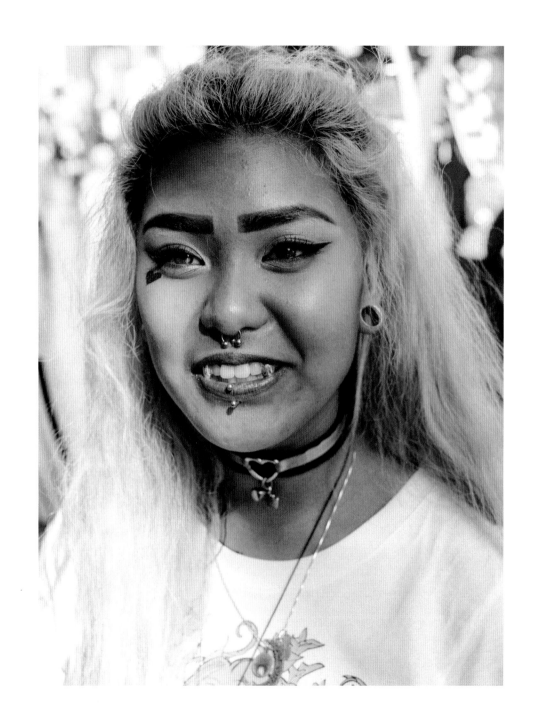

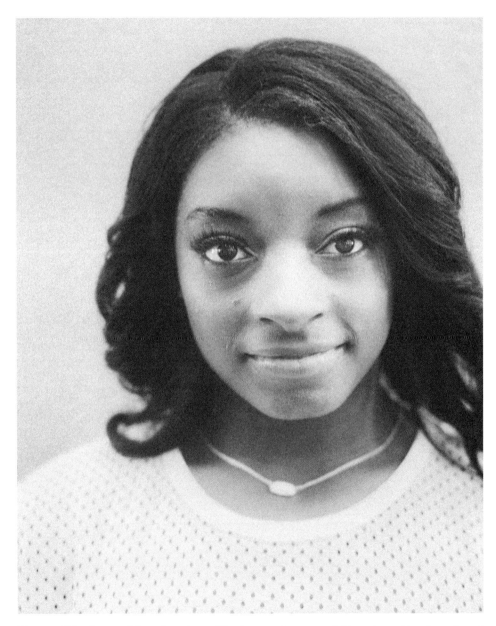

Simone Biles is a real American hero. She is one of our great Olympians. Her fame is not from Hollywood. Her fame is hard-earned through personal excellence.

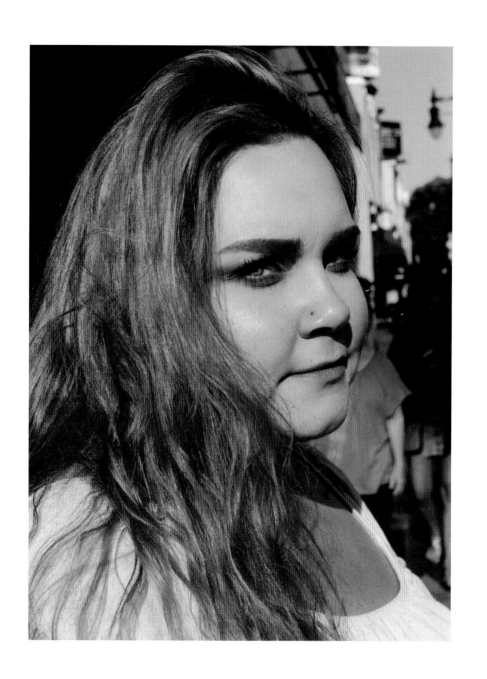

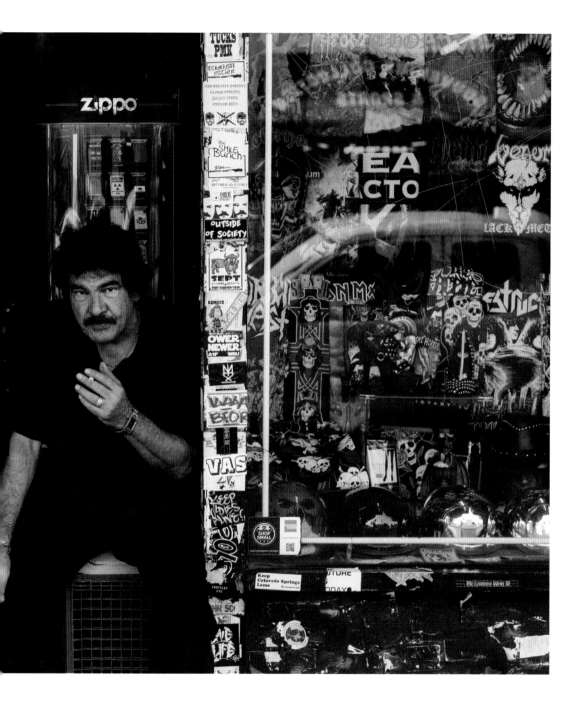

THE A-LIST ACTOR

I got a call from my agent when I was at work, waiting tables with the rest of the Los Angeles actors. When I got home, I saw the light on my answering machine blinking, and my stomach shifted into almost a semi-nauseated turbulence. I hated going on auditions.

The casting process is so maddening for actors on the front lines with no résumé. You are damned if you do and damned if you don't.

Casting directors might have had a disagreement in the morning with their friend, colleague, or parking meter maid, and they will take it out on you if you strike the chord wrong. It's even worse when you look like someone they don't like. I would walk on eggshells, even though I had some work under my belt . . . but starting out, I would get these panic attacks when the phone would ring.

Well, sure enough it was a "general" meeting. I was relieved because that meant I would get a free coffee and possibly meet someone who could point me in the right direction. Although, most "general" meetings can sometimes get spooky when intentions are unclear.

I went to this "general" meeting only to find out that the casting director I was meeting with had requested another actor who looked like me to meet them. So when I walked in, I was greeted with a hint of confusion and a way better-looking version of me in the mezzanine.

That painfully awkward moment almost left me defeated, until the assistant chased me down and told me I would get to read for this character. My doppelgänger was right there, stretching for the race.

Casting offices are always different. You never really know what will happen.

Long story short, I got the job because the actor they originally wanted had too much "fragrance" on in the room and that iced everyone out. I'd like to believe they hired me for my charm and theatrical talent, but that was my first big break, caused by a complete fluke. Now, countless roles later, I am very grateful to be part of this crazy business, but I never forget where I came from—a coffee meeting with no "fragrance."

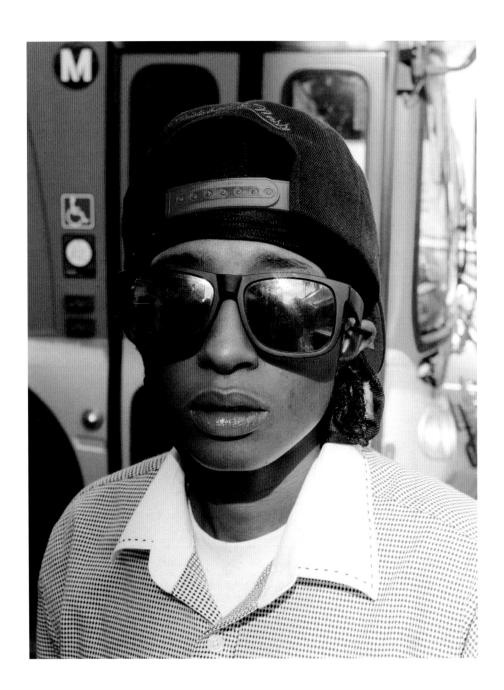

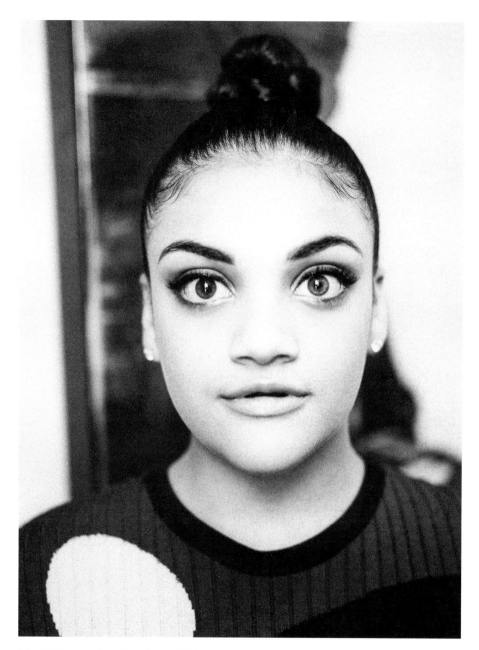

Laurie Hernandez: American Gold.

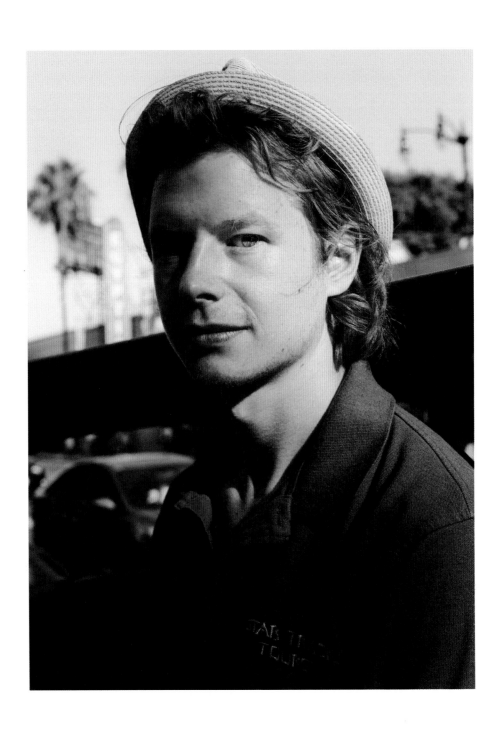

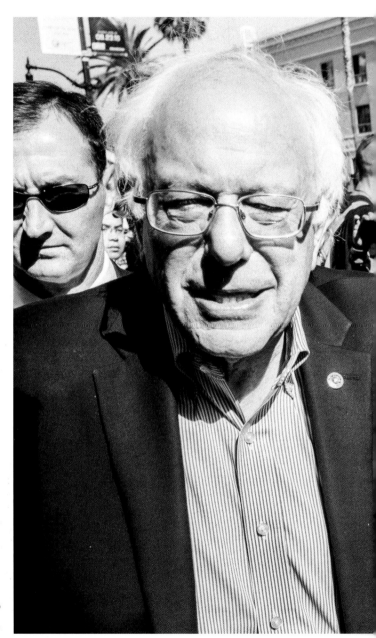

Even Bernie felt the need to
come to Hollywood Boulevard.

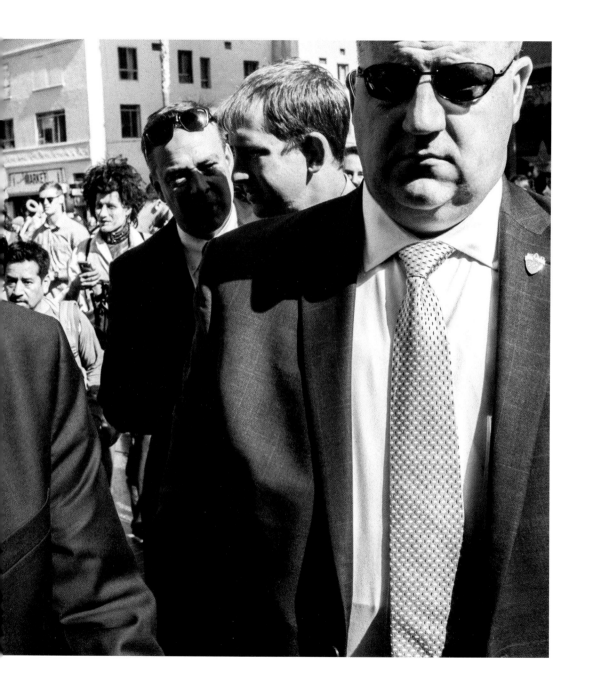

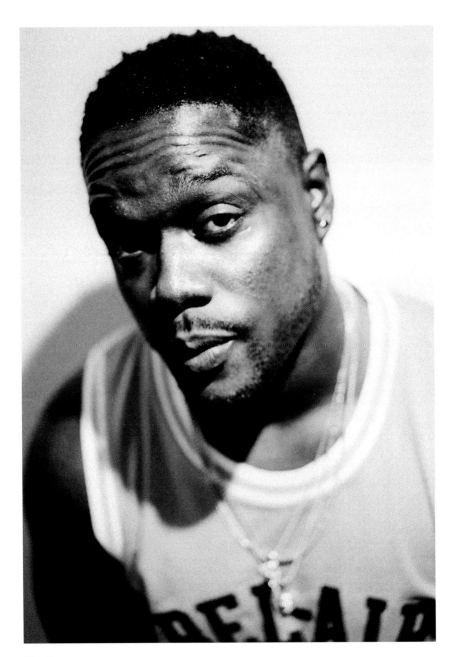

Klarity.

Blake Gray.

Modern-day paparazzi.

YOU'RE OFF

You're off somewhere in Hawaii
you're on some island
you think about me from time to time
and smile

You hear a song and remember
cold summer mornings
before the fog would lift
and we would still be up from the night before
making plans

You're out making your fortunes and
checking places off your map
you're on some binge of specialty cookies
and home-baked goods
bought from roadside stands

You pause at sunsets
to take in what we talked about

back here in LA
when we were younger
when you still trusted people
when we were still both new

You know my dad died twice
and it makes you cry
to lose your keys

But you're off somewhere
in some doorway
sitting in some lobby
down some staircase
briefly
lost in thought
and you can't quite figure out what it is

I'm writing to tell you

it's me.

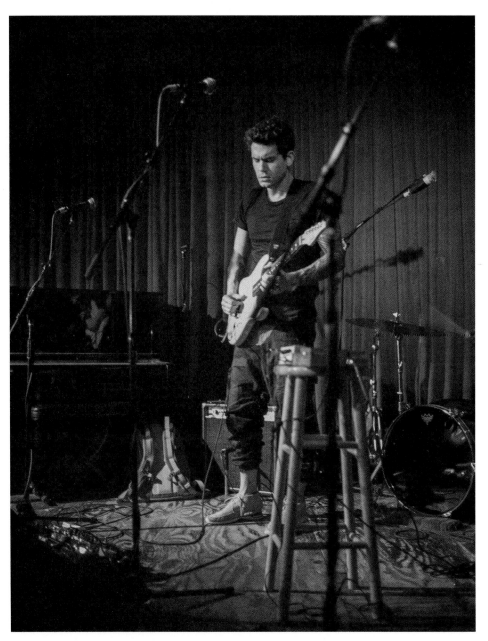

John Mayer at a Hollywood gig.

At 5:45 a.m., a lone citizen dug out Trump's star from the Walk with a pickax. This is the aftermath.

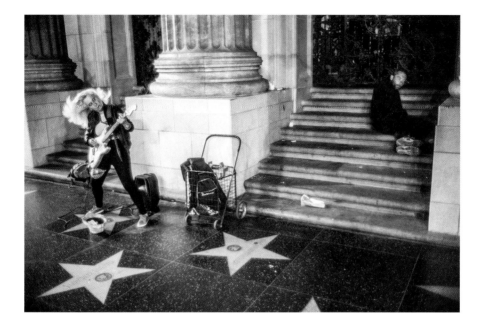

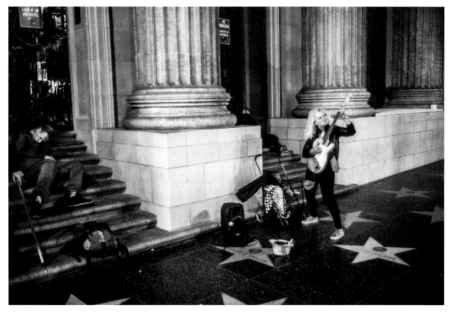

Across the street, there is always an oscillating theme.

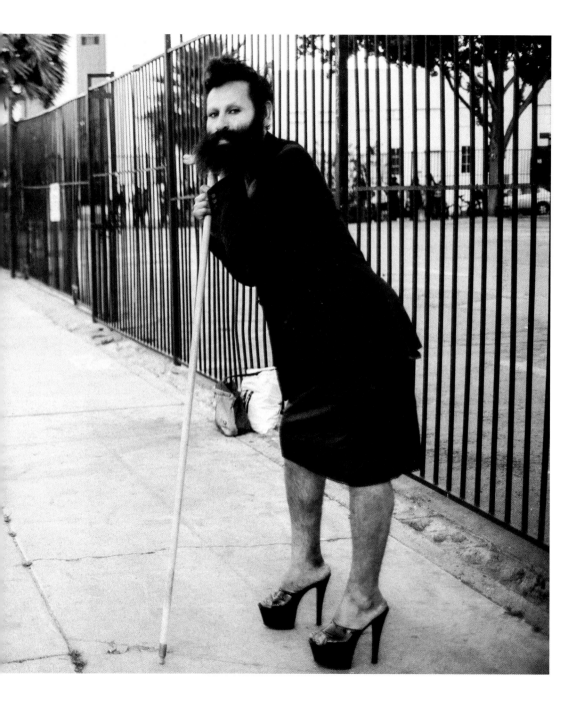

INHERITANCE

I have been living in Hollywood since 1972. I was working at a retirement home that is now the Hotel on Sunset Boulevard. I never wanted to be an actress or anything in the public eye. My time was spent helping older people live out the rest of their lives in comfort. I met a very old, kind gentleman when he would come visit his friends every weekend. I was just an average girl, but he would always talk to me about show business and tell me I should be in movies, or model. He told me that I was the most beautiful person he had ever seen, inside and out. He eventually asked me to have dinner with him. It turned into a normal arrangement: we would have dinner and he would tell me his stories about his grand life. When he died, he left me his estate, which shocked me. He had no other family. Suddenly I was responsible for more money than I had ever imagined. So now I just live day by day between Bel-Air and the Hollywood Hills. A dreamland that my wildest dreams have yet to catch up with. I think about him every day and how he changed my life. I'm a spoiled old lady now, but don't worry. . . . I have someone to leave his estate to. My cats!

Bella Thorne: a starlet.

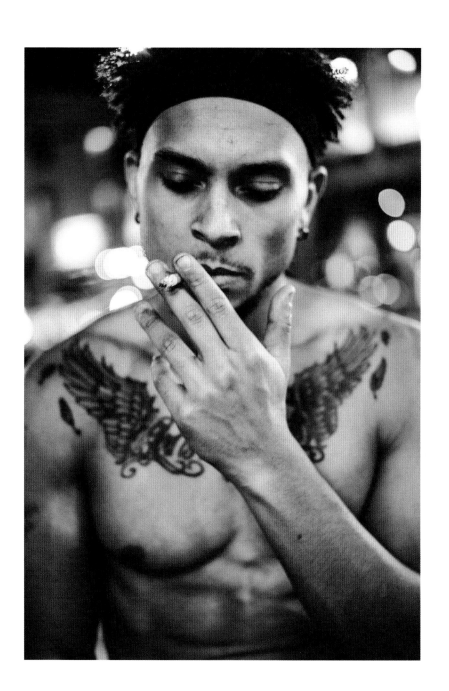

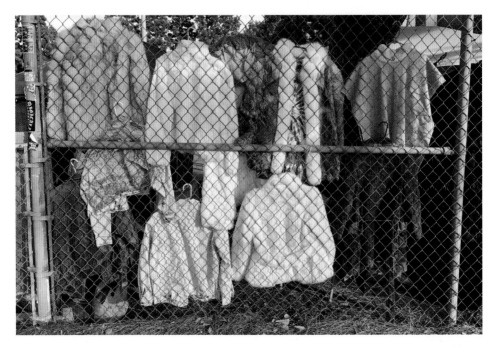

Coats of many colors.

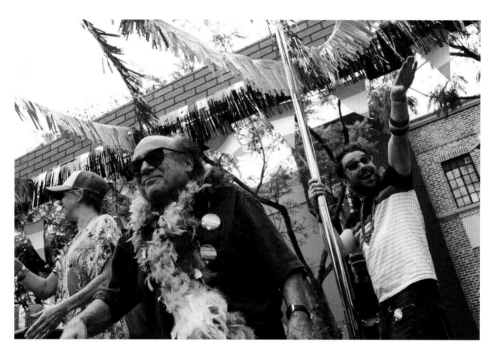

Danny DeVito and Charlie Day in West Hollywood.

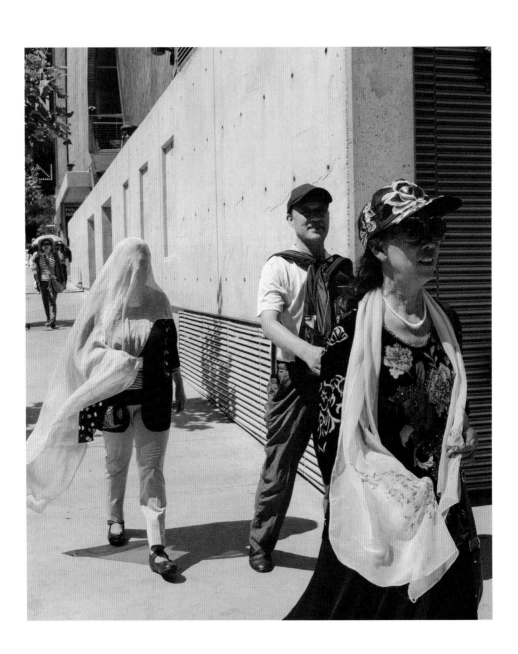

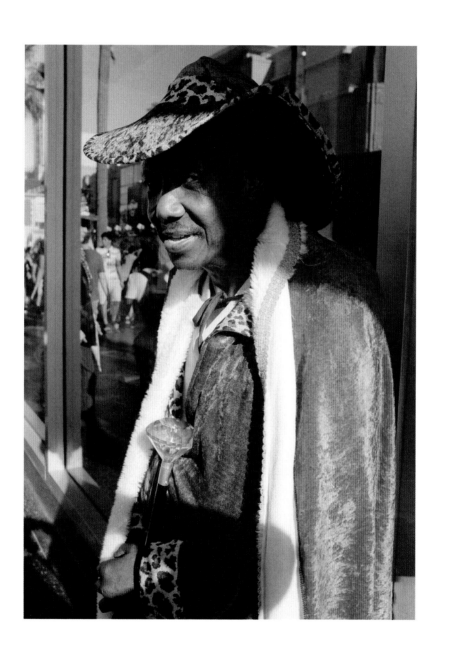

Welven Harris is known for a prank call titled "Deez Nuts."

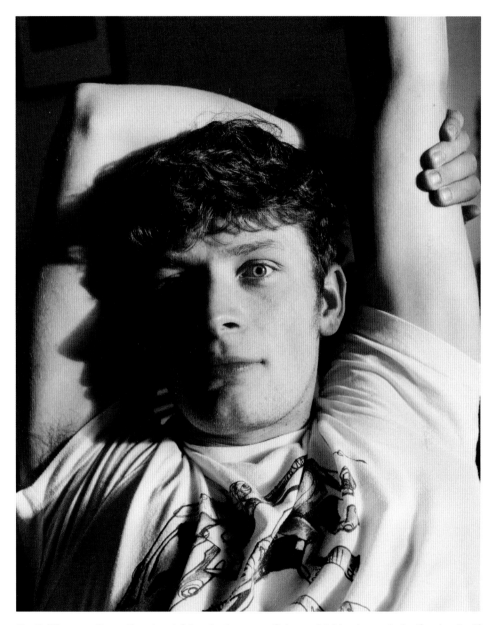

Brett Dier, my Canadian best friend whose craft brought him here, is half actor/half comedian.

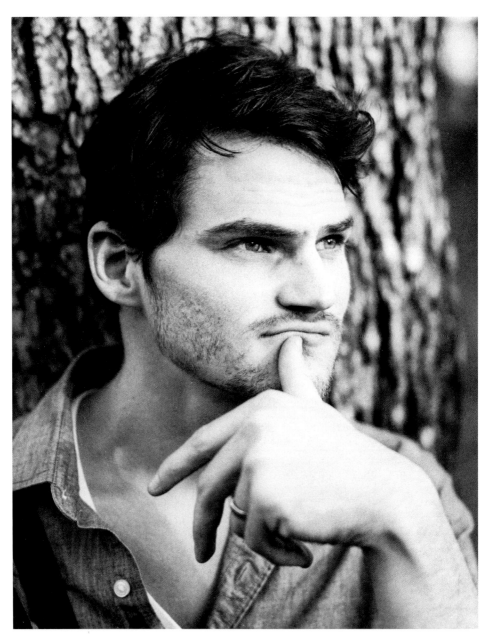

Julian Smith: writer, director, actor, photographer, father, and artist.

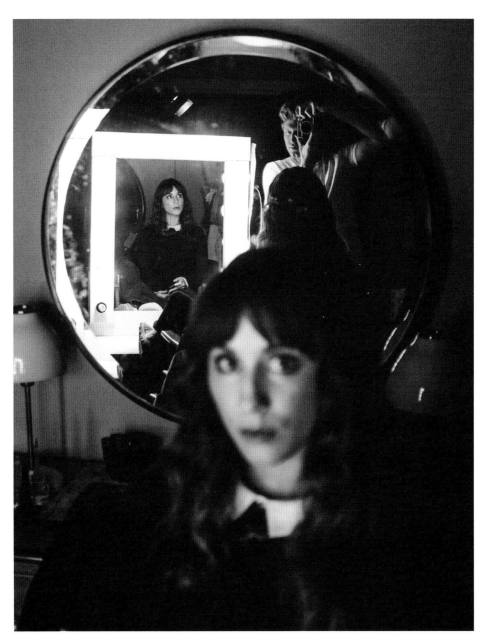

Troian Bellisario: writer, director, actor, artist, producer, wife, and philanthropist.

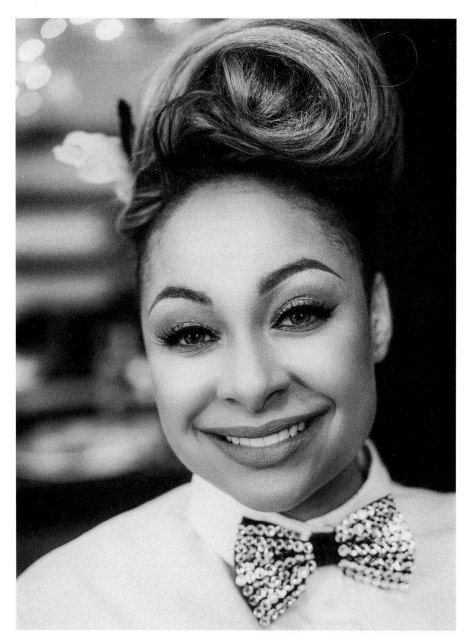

Raven-Symoné.

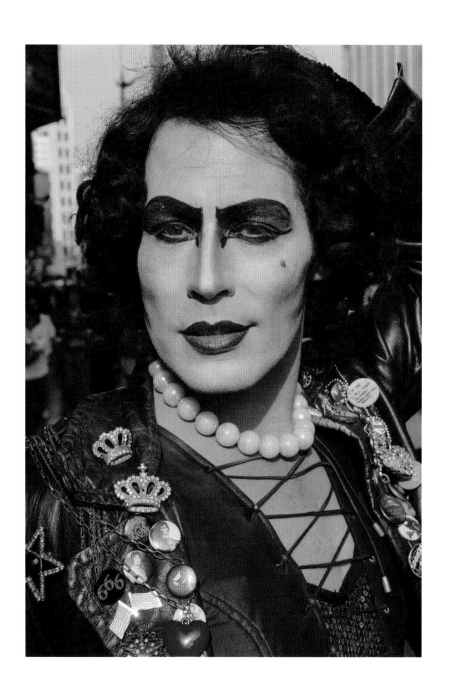

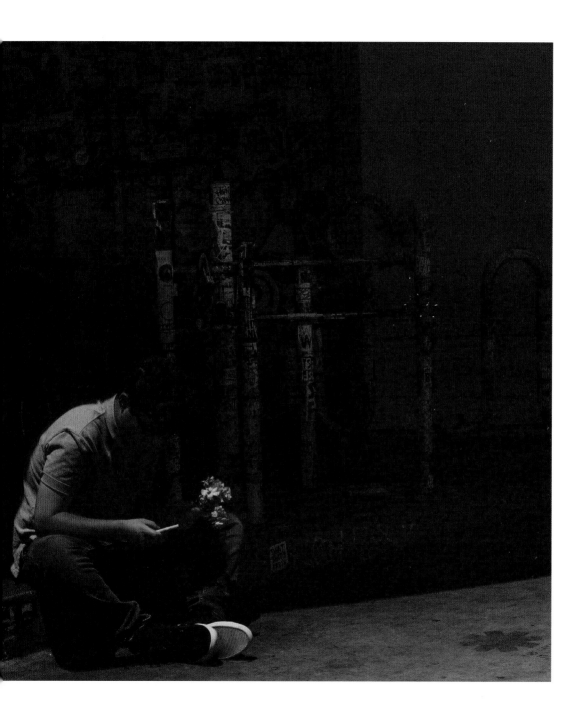

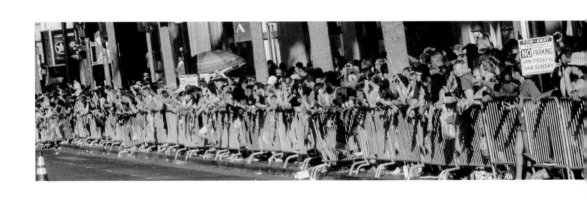

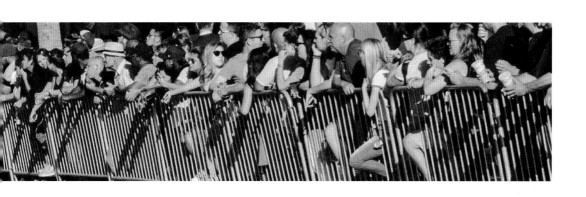

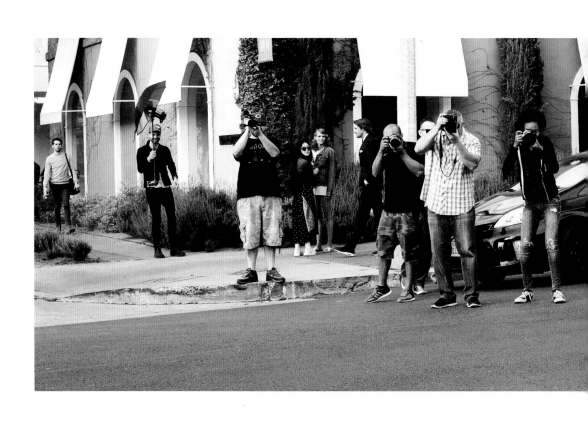

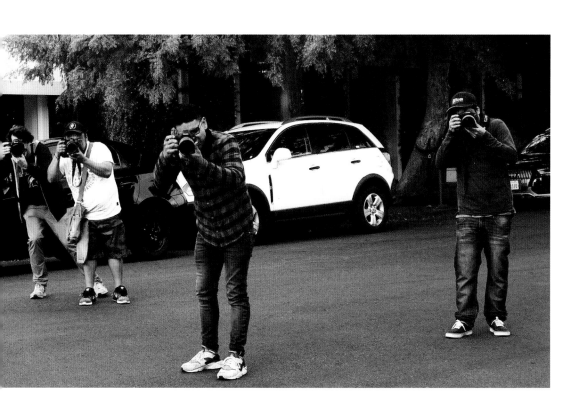

LOVE YOU MORE THAN FOR FOREVER

My life was filled with beautiful people crying about simplicities in the bathroom. I have never been the person who could fall in love, or even get butterflies. If anything, it was the butterflies crawling around inside me, trapped and panicked in a frenzy of retreat. The thoughts that kept me up at night about loving someone were dangerous. It felt like the ultimate sacrifice to give yourself away into the ether of madness, a madness that may never be realized by the person you gave up everything for and your ambition would hush. I dreamt of roaming the world and ending up in India and driving a rickshaw at eighty-eight. Every day was endless coffee and contemplations about why I wasn't where I wanted to be here in Hollywood. I would look at strangers and ask politely with my eyes if they could save me from my atrophy.

Roaming around the desert of Los Angeles, it dawns on me that most people don't realize how desolate this city is until they walk around it. Anyway, I didn't want to fall in love; it didn't appeal to me. So I walked around and cuddled with the pavement. I lost track of the days with the kindness of normality. Nothing really ever happens until it does.

It was a simple night. I was wandering back to my side of the hill and not paying complete attention, walking against oncoming traffic; this random geriatric woman was unable to see how close she was getting to the curb. The world around me swirled into a curtain of Las Vegas flashbacks and kaleidoscopic blurs. You know the one: tons of tiny lights spinning like a tape rewinding, and your eyes are at the center? My soul followed closely behind as I hit the pavement. I couldn't feel any pain at all, but there was a pressure

immediately that was so foreign to my comatose that I usually move with. I won't go into the details, but I thought life was hard before I couldn't walk. Now I can't really do anything I wanted to do before. I roamed around nicer neighborhoods and areas, begging for scraps and pennies on the dollar. A true crippled sad clown who never found love. Wait, it gets better.

So, years go by, and I live my new jaded lifestyle with a bit more ease, albeit with a few pitfalls of being unambitious. I am sitting on a corner, and a beautiful young girl comes over to me—she was very beautiful. She looked how one might picture a celebrity or a wealthy ingénue. She walked right up to me and in perfect English asked me why I was in a wheelchair. She was not American, a tourist, visiting from Asia. I told her my brief story, and she stopped me and told me her father is a very smart businessman, but that he is brutal and doesn't take the time to help anyone out who really needs help. She asked me if I had a bank account, and I told her I didn't and that I only had thirteen dollars to my name (most was in coins). She got on her pocket phone and called someone and spoke with authority, I assumed in Chinese. She kept making eye contact with determination. Most people don't even talk to me, let alone make eye contact. I unintentionally began to cry, because I got so nervous and embarrassed. A car pulled up, and a man, I assumed he was her driver, walked over to me and helped me into this big brand-new black car. The woman told me she was taking me to the bank to open an account for me and that she would monitor it. I thought this was a joke, but sure enough she brought me to the bank. The bank manager was very upset and didn't quite understand her idea. I also had no forms of ID on me or proof that I was an American citizen, even though I was born in the US.

The woman didn't care and wanted to help me, so she put me in a hotel for the night until she settled all my new chores for obtaining citizenship. The next part is boring, so we can skip it.

But here is the part I was getting at, about love. Love is a construct of a diseased mind. Love is a contract of a blind pen. Love is a girl dying of cancer with all the money she could never spend and a father who never spent time with her. This girl made sure I was taken care of for the rest of my life. I still don't fully understand how, but she did. When she passed away, I heard from a letter. It was then that I understood why I was so afraid of love. I was so stunned that someone came out of the nowhere and nothing and offered me a second chance because she didn't have one. We never became close friends or anything, but I do remember the last time I saw her, I had said something like:

"It's a beautiful day today, but it looks like it will rain."

And she answered back with:

"If you think it's going to rain, it probably will."

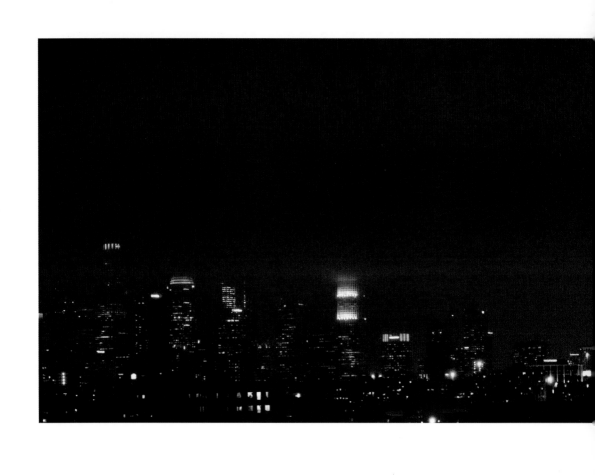

I wonder how many of them
are just getting here.

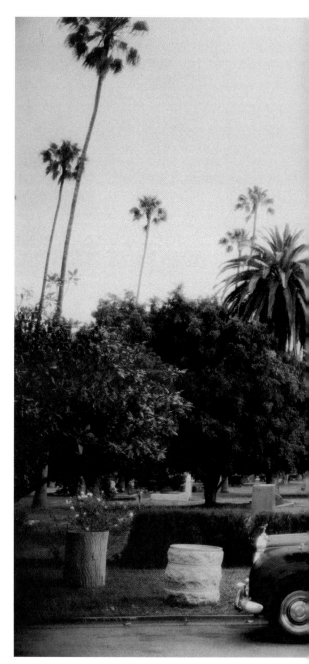

Hollywood Forever Cemetery is the natural destination for many celebrities to finally rest. Here we are. Destination found.

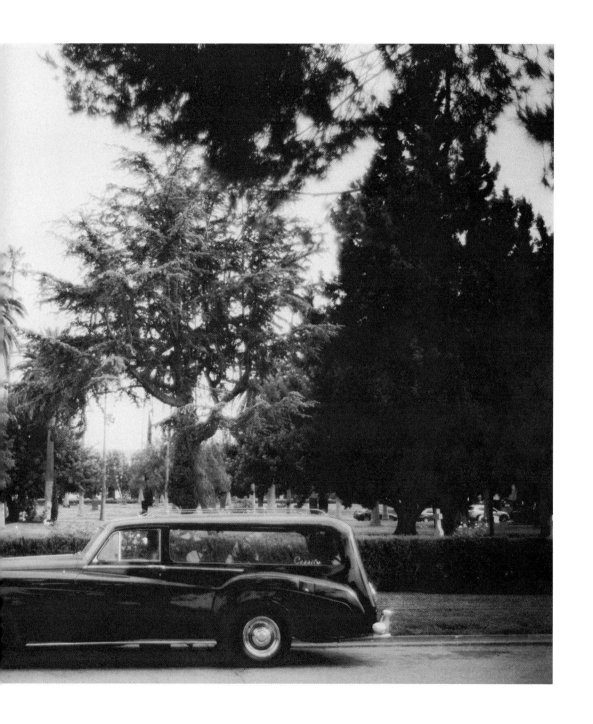

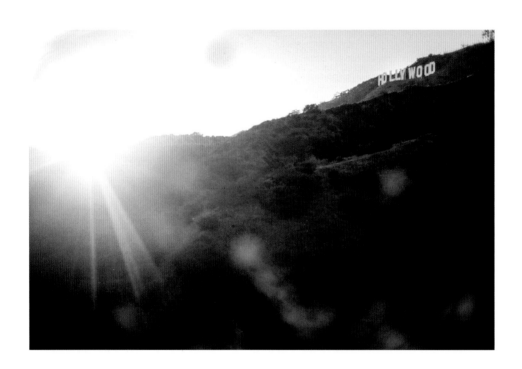

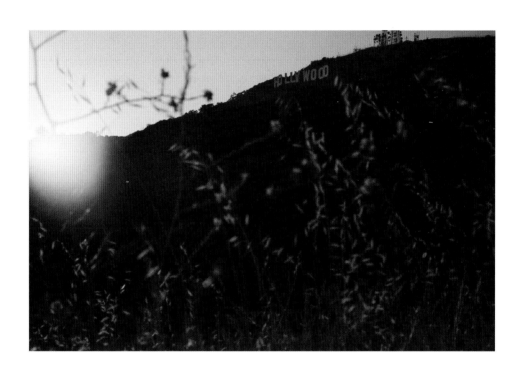

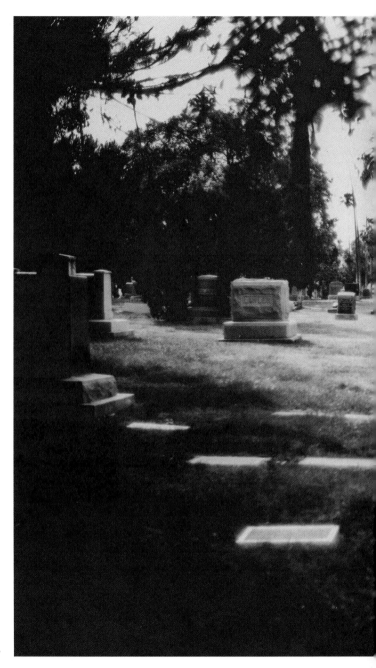

Rest in peace; your work is done.

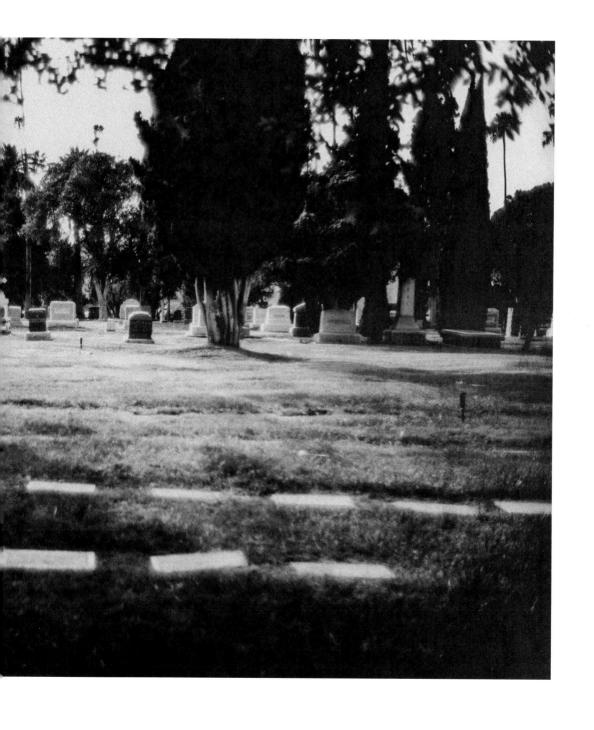

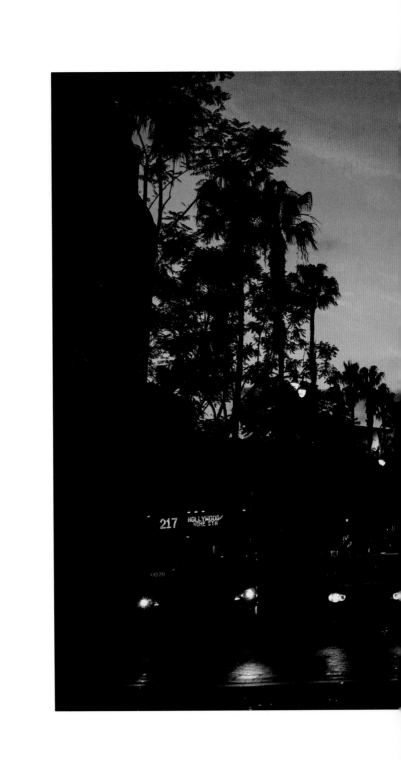

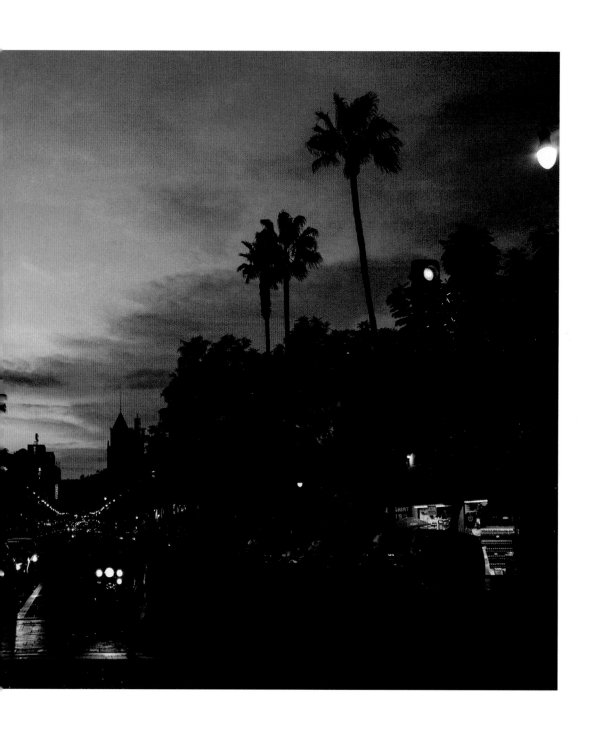

THIS FOREVERLAND

These are the days

so few

and far between heavens.

Why did I jump in this puddle?

I am lost, looking for a way back in.

She was as alone as I was, waiting for a bus. She was waving at a puddle beneath her feet.

Then she looked at me.

No one looks at me.

The bus arrived and she grabbed my hand. It was the first time I had ever been grabbed by a girl, and I had no idea where she was taking me. We rode only two stops, and all the while, her questions had me tripping over my answers and her gaze was burning through my skin. She stared at me with such a power that she could kneel me at any second with a wink, or a bite of her lip.

We escaped the bus, and she turned to me and whispered, "I want to kiss you," then retracted: "I'm sorry." She didn't kiss me. She walked in front and I followed. She told me personal things. She told me she was broke. She didn't trust her parents and she hated her apartment on Argyle, because the backyard was the freeway. The car noise wasn't the lullaby she had promised herself it would be. She was from another overworked city and, possibly, another time.

I walked her up to her apartment. She told me she had decided to show me something. She promised I had never seen it before.

My mind went to places.

In her courtyard at dusk was a tile fountain. Inside, we stood as mirror images of ourselves. She examined us to be something different in the reflections of the water. She told me that we were seeing an alternate reality of perfection. Our reflections in this dark water were exactly who we wanted to be. We just needed to switch places sometimes. She jumped in. I did too.

She hung out with me all summer and we got close. She even took me to a friend's wedding as her guest. We danced and I put my hand on her back. When she smiled, her eyes would close.

But only for a second.

She bought a pack of beer and we drank it under the freeway together and she sang show tunes in lonely whispers. I smiled and so did she. We went up to her roof.

We watched the sunset. She told me she loved this.

She was never sad around me.

She was never lonely.

We started doing everything together.

She always looked into puddles. I started to understand.

The vanity of this city keeps us all wondering what we look like, and what others see us as. Without mirrors or reflections, Hollywood wouldn't want to exist. It needs us to see ourselves at our best and at our worst.

We keep chasing our dreams with every glance of eye contact. It is in these reflections where we build the confidence to do the things we haven't done. Where we see who we want to be . . . or who we want to escape.

The world inside the reflection is always a glimpse of the perfect life, and sometimes we can switch places. More and more often now.

We would hike up Beachwood Canyon. Sometimes to catch a glimpse of a wild black horse close to the Hollywood Sign. A hiker told us in passing about the folklore of a wild stallion that lives off the land. The Hollywood Horse. It became an inside joke. It became a lifestyle. We laughed, a lot.

We started hiking more to find new places. Griffith Park in the spring.

She kept staring at me. We ate peanut butter sandwiches on a park bench next to the James Dean statue. She kissed me. I kissed her back.

I got nauseous. She called it butterflies. I didn't sleep.

Everything worked. She told me that we were now in our perfect life all the time. She welcomed me to this "foreverland." Our dreams became reality.

We talked about kids' names in the 101 Coffee Shop. She drank coffee; I didn't. She told me that she loved our differences, and I thought she said she loved me.

We were happy.

She told me she loved me later that day.

I said I loved her back.

We never got tired of each other. Young love.
Move in.

Carpets, Chairs, Dishwater.

She is so beautiful when it rains in LA.

We rescued a kitten together in Laurel Canyon.
We named it Bugs because of the fleas.

We all scratched through the pet stores.
We all fell asleep in a lump.

A lump of coal.
Christmas in California.
Plastic Trees.
Eighty-one degrees.

A lump in her throat.

We called the family.
We were surrounded.

She was diagnosed in the winter and

she died a year later.

In between that time . . .

The cat ran away. Our friends all cried a lot.

I stayed up at night and walked around, trying to find Bugs.

I was really looking for this foreverland.

I was trying to switch back.

She told me not to cry

She told me to be strong

She told me so many things I have saved with photos I can't look at.

Voice recordings I still can't play.

She got further away. I stayed in place, spinning.

She walked with me down Hollywood Boulevard and watched the
street performers. They started to remember our names.

We didn't tip them. They understood.

She told me she would have a Hollywood star on the Walk of Fame.

She told me it was easy. She told me she would just switch her name
to one that's already printed. Someone not famous anymore. She did.

We celebrated her star.

She said she would always be around. She promised she would visit this foreverland from wherever she had to go next.

She didn't want to leave me. We held hands every second.

When she died, I drove home.
The sunrise was in my eyes. Orange and pink blinding me.
I needed to call someone.
I only wanted to call her.
It's been twelve years and I wish for one more day.

Never got over it.

I feel older but incomplete.
I still find myself looking in reflections of water,
always taking the bus.
Searching for her.
Waiting for her.
So, these are the days
so few
and far between heavens.
Looking for this foreverland.
Lost in this foreverland.

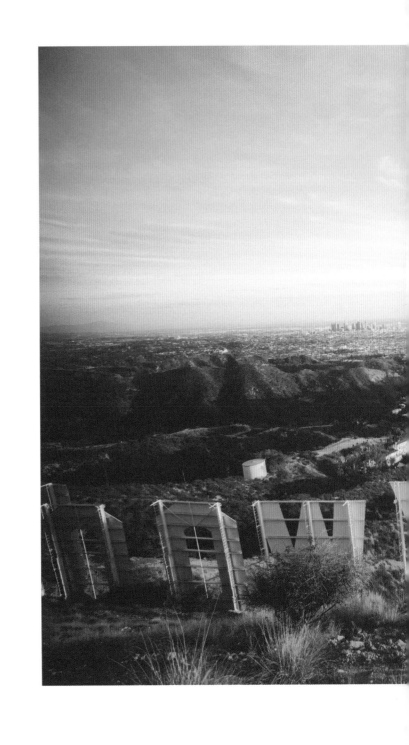

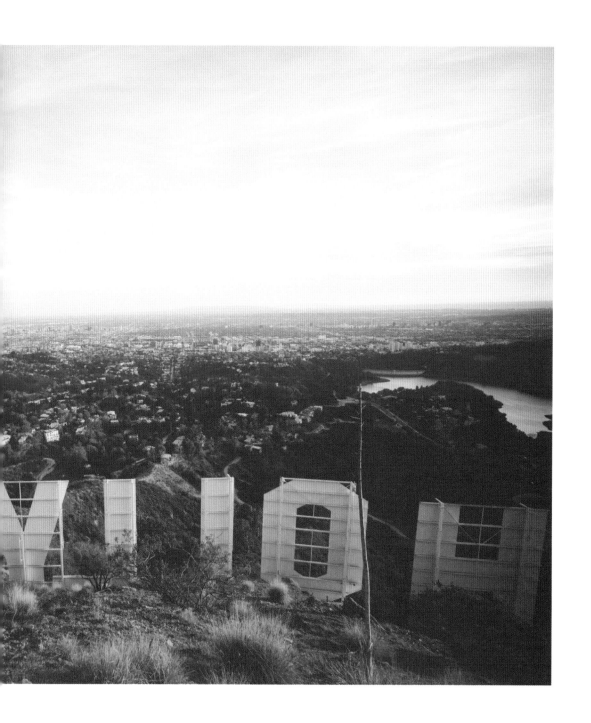

THE PERFECT DAYS

Her lips lightly chapped against the sweet warm air as she explained her perfect day would be filled with destinations. She holds my hands with her eyes, and her light hair blankets her shoulders. It's an odd feeling to tell a stranger you see them, a scary excuse for excitement. Are we all so endlessly alone?

To fight against the grip of loneliness, do we all linger on the edge of connection?

Her eyes are two small planets orbiting me, filled with life and yet so far away. I can only now make out their oceans deep enough to swim in, and open my own eyes underneath. The land, an archipelago in appearance, holds my gaze as I count out the possibility for survival.

Can the feeling last? This one feeling of hope—that we are not alone in these worlds we live on. These universes we separate ourselves with.

I am flying lower. A calculated buzzing hovers over new terrain.

She is an untouched shoreline, and I am a crash landing in silence.

These perfect days sometimes end with plum midnight skies. The one complete with a lazy moon ornately hanging in the tree. Light pollution's gradation into space.

When we are visited by out-of-towners, we are shook by their dreams that were once our own.

Sometimes we leave planet Hollywood only to see it from far away and wish ourselves back once more. The little center of its universe surrounded by stars, bursting and fading. Orbiting a soft light of upcoming travelers.

It's in this darkness that we feel the light around the corner.

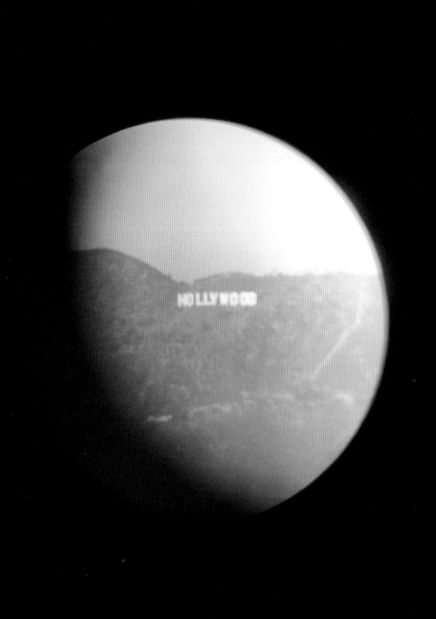

ACKNOWLEDGMENTS

I would like to acknowledge:

The people in this book, I may or may not know you, but you help tell the unique story of Hollywood.

My mother and my father, Joan and Phillip, who supported my passion and love of the arts throughout my life and urged me to go on adventures with my camera and then inspired me to share my experiences with others. Thank you to Minin for being Minin.

My book agent and friend, Todd Shuster of Aevitas Creative Management.

George Witte, Sara Thwaite, and everyone at St. Martin's Press for your energy and focus bringing *Hollywood* to life and shaping it into something special. My attorney, Karl Austin, and my legal team at Jackoway. Jeffrey Craig Miller of Miller Korzenik Sommers LLP. Nanci Ryder and my team at BWR. Thank you, Darren, Barbara, and Brent of my financial team. My APA team, led by Jeff Witjas, Paul Santana, and Barry McPherson, your commitment to my work is respected.

Mike Rose and Debbi Fields, I know Mike would be proud of this book and I'm glad I was able to share it with him while I was working on it. Thank you Keith Calkins, my photography confidant. I'm so glad you were there during some of these inspiring moments. We now have so many stories and epic memories to look back on. You're an amazing friend and a very gifted photographer. Thank you to Philip Cuenco for helping me use my camera to the fullest. Thank you to Ali. Thank you Samy's Camera for being so clutch in any repairs, parts, cameras, and processing. Tibor, here is the second book, baby!

Thank you Icon Photo Lab, Color Resource Center NYC, Fuji Film, and Kodak.

Huge thanks to my Leica family, the APO on the M is the perfect marriage.

Thank you to all my friends who appeared in the book and who have supported my art so rigorously for so long. Thank you to everyone I have worked with as an actor, your support has allowed me to express my art in so many ways.

Thank you Konrad, my manager, for always steering me toward my dreams.